lorna simpson

lorna simpson

OKWUI ENWEZOR

Curator's Foreword by HELAINE POSNER

Essay by HILTON ALS

Conversation with the Artist:
ISAAC JULIEN and THELMA GOLDEN
Preface by SHAMIM M. MOMIN

ABRAMS, NEW YORK, IN ASSOCIATION WITH THE
AMERICAN FEDERATION OF ARTS

This catalogue is published in conjunction with *Lorna Simpson*, an exhibition organized by the American Federation of Arts. The exhibition is made possible, in part, by grants from The Andy Warhol Foundation for the Visual Arts, the Peter Norton Family Foundation, the National Endowment for the Arts, the Lily Auchincloss Foundation, Inc., the Martin Bucksbaum Family Foundation, and The Barbara Lee Family Foundation Fund at the Boston Foundation.

Guest Curator: Helaine Posner

FOR THE AMERICAN FEDERATION OF ARTS:
Project Manager: Michaelyn Mitchell
Coordinating Curator: Yvette Y. Lee

FOR HARRY N. ABRAMS:
Project Manager: Margaret L. Kaplan
Design: Barbara Glauber and Emily Lessard, Heavy Meta

LIBRARY OF CONGRESS CATALOGING-IN-PUBLICATION DATA
Enwezor, Okwui.
 Lorna Simpson / Okwui Enwezor; curator's foreword by
 Helaine Posner; essay by Hilton Als; conversation
 with the artist, Lorna Simpson, Isaac Julien, and Thelma
 Golden; with a preface by Shamim M. Momin.
 p. cm.
 "This catalogue is published in conjunction with
 Lorna Simpson, an exhibition organized by the American
 Federation of Arts."
 Includes bibliographical references and index.
 ISBN 0-8109-5548-2 (hardcover : alk. paper)
 ISBN 1-885444-32-1 (softcover : alk. paper)
 1. Documentary photography—Exhibitions. 2. Simpson,
 Lorna—Exhibitions. 3. African Americans—Portraits—
 Exhibitions. I. Simpson, Lorna. II. Posner, Helaine.
 III. Als, Hilton. IV. Title.
TR820.5.E62 2006
779.092—dc22

 2005029616

Printed and bound in Singapore
10 9 8 7 6 5 4 3 2 1

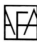

American Federation of Arts
41 East 65th Street
New York, NY 10021
www.afaweb.org

HNA ▮▮▮▮▮
harry n. abrams, inc.
a subsidiary of La Martinière Groupe
115 West 18th Street
New York, NY 10011
www.hnabooks.com

Front cover: Lorna Simpson, detail of *Corridor (Mirror)*, 2003.
Back cover: Lorna Simpson, detail of *Corridor (Mirror)*, 2003.

EXHIBITION ITINERARY
Museum of Contemporary Art, Los Angeles
April 16–July 10, 2006

Miami Art Museum
October 13, 2006–January 21, 2007

Whitney Museum of American Art, New York
February 8–May 6, 2007

The Gibbes Museum of Art, Charleston
September 7–December 2, 2007

acknowledgments

It is a privilege to celebrate the work of Lorna Simpson with this full look at more than two decades of her production, beginning with her earliest photograph and text works and ending with her film and video installations of the last few years and most recent photographs. We are delighted to present this beautiful and provocative body of work to a broad national audience.

I wish to first acknowledge Helaine Posner, AFA Adjunct Curator of Exhibitions, who proposed the idea for this wonderful exhibition and served as its curator. Helaine wrote the curatorial foreword and was joined in the publication by Okwui Enwezor and Hilton Als, who each contributed essays; by Isaac Julien, Thelma Golden, and Lorna Simpson, participants in the "Conversation with the Artist"; and by Shamim M. Momin, who wrote the preface to the conversation. Their contributions greatly enrich our appreciation of Simpson's work.

Everyone at the AFA played a part in the realization of *Lorna Simpson*. Thomas Padon, former Deputy Director for Exhibitions and Programs, was instrumental in shaping the project and overseeing its development. Yvette Y. Lee, Curator of Exhibitions, superbly organized all aspects of the project. Ms. Lee was assisted by Curatorial Assistants Julia Perratore and Theo Walther, who have worked meticulously in handling loan requests, checklist development, and photography. Michaelyn Mitchell, Director of Publications and Design, skillfully managed production of this handsome and important catalogue with our publishing partner, Harry N. Abrams Inc. Assisting Ms. Mitchell was Alec Spangler, Editorial Assistant, who ably took care of many details related to the production of the catalogue. Kathleen Flynn, Head of Exhibition Administration, carefully oversaw many of the details of the exhibition tour. Kathryn Haw, Director of Corporate and Foundation Relations, and Anne Palermo, Grant Writer, are to be commended for their efforts in preparing proposals that led to funding for the exhibition. I also want to acknowledge Anna Hayes, Head Registrar; Dottie Canady, Registrar; and Suzanne Burke, Director of Education.

We would like to acknowledge Barbara Glauber and Emily Lessard of Heavy Meta for their aesthetic sensitivity and skill in designing a book that responds so sympathetically to the subject matter. We also very much appreciate the expertise and enthusiastic support of Margaret L. Kaplan at Harry N. Abrams, Inc.

We extend our deepest thanks to Lorna Simpson for the beautiful work she has created, and we are particularly indebted to all those who made the loans to the exhibition possible, in particular Sean Kelly, Cécile Panzieri, Amy Gotzler, and Deborah Vilen at the Sean Kelly Gallery.

Our thanks go to the Andy Warhol Foundation for the Visual Arts, the Peter Norton Family Foundation, the National Endowment for the Arts, the Lily Auchincloss Foundation, Inc., the Martin Bucksbaum Family Foundation, and the Barbara Lee Family Foundation Fund at the Boston Foundation for their generous financial support, which helped make this exhibition possible.

Finally, we recognize the museums participating in the tour of this important exhibition—the Museum of Contemporary Art, Los Angeles; the Miami Art Museum; the Whitney Museum of American Art, New York; and the Gibbes Museum of Art, Charleston. It has been a pleasure to work with them, and we thank them for being such enthusiastic partners.

JULIA BROWN
Director
American Federation of Arts

curator's foreword

Lorna Simpson, one of the leading artists of her generation, has produced an important body of work that balances the poetic and the political, the ambiguous and the specific. For more than twenty years, her photograph and film works have been recognized for their high level of conceptual sophistication and social awareness.

Simpson first became well known in the mid-1980s with large-scale photograph and text works that are both formally elegant and subtly provocative. Focusing on the female figure and often accompanied by evocative texts, her signature works of that period are characterized by a sensitivity to nuance in pose, gesture, and demeanor. In the mid-1990s, she began to concentrate on creating mural-scale multi-panel photographs on felt. Titled "Public Sex," these photographs, which depict urban locales and eliminate the presence of the figure, evoke feelings of melancholy and loss. Their shadowy, foreboding atmosphere, suggestive of stills from film noir, led the photographer and former film student to take on the challenge of creating moving images, which also allowed her to expand the narrative content and complexity of her work. The most recent development in the ever-evolving trajectory of the artist's work has been the reintroduction of photography to her artistic practice.

Simpson has received much critical attention, and facets of her work have been included in numerous exhibitions both nationally and internationally. *Lorna Simpson* is the much-deserved mid-career survey of her remarkable achievement over the past twenty years. I am delighted to have had the opportunity to work on this project and would like to thank the artist for hours of insightful conversation and for the pleasures and instruction I have derived from her work.

I would also like to acknowledge art critic and historian Okwui Enwezor and cultural critic Hilton Als for their valuable contributions to this book. Enwezor provides an astute examination of Simpson's photographic work as an essentially philosophical endeavor addressing racialized and gendered modes of representation within a broad visual and literary context, while Als explores the influence of cinema on Simpson's photograph and film work as well as her role as a director of women, one of film's and the artist's most compelling subjects. In a wide-ranging conversation with curator Thelma Golden—with a preface by Shamim M. Momin—Simpson and artist and filmmaker Isaac Julien offer their perspectives on a variety of shared formal concerns and political issues. I extend my gratitude to them all.

Finally, I would like to express appreciation to my colleagues at the American Federation of Arts, especially Julia Brown, Director; Thomas Padon, former Deputy Director of Exhibitions and Programs; Yvette Y. Lee, Curator of Exhibitions; Michaelyn Mitchell, Director of Publications and Design; and Kathryn Haw, Director of Corporate and Foundation Relations, for their great support and organizational skill in bringing this important contemporary project to fruition.

HELAINE POSNER
Adjunct Curator of Exhibitions
American Federation of Arts

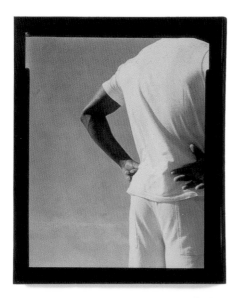 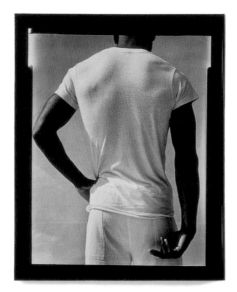

so who's your hero—
me & my runnin buddy

how his runnin buddy was standing
when they thought he had a gun

how Larry was standing when he found
out

when Buck was being himself

and on saturday when Calvin pretended
he was that famous football player
he could get into any club or
anywhere he wanted

for the past 6 months

work this week is temp.
high risk or low pay

Mr. Johnson walks out

say girl—
ain't you color film at lea

Cecile with hands on hips got angry &
old him about himself in the kitchen

he stood by the refrigerator

whenever he hears *Biko*
the way he walks down any street

sometimes Sam stands like his mother

Gestures/Reenactments, 1985
6 gelatin silver prints, 7 engraved plastic plaques
Photographs 48¼ x 39¼ inches each,
252 inches overall
Collection Raymond Learsy and Melva
Bucksbaum, Connecticut

IS SHE AS
PRETTY AS A
PICTURE

OR
CLEAR AS
CRYSTAL

Twenty Questions (A Sampler), 1986
4 gelatin silver prints, 6 engraved plastic plaques
Photographs 24 inches each (diameter), 99 inches overall
Courtesy the artist and Sean Kelly Gallery, New York

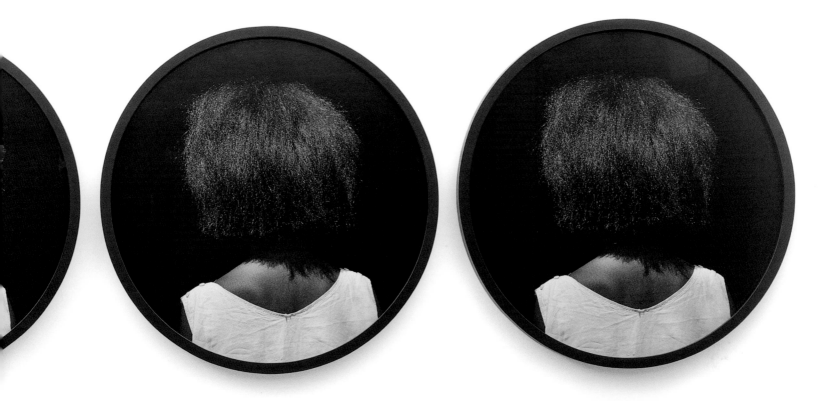

OR
PURE
AS A LILY

OR
BLACK
AS COAL

OR
SHARP
AS A RAZOR

Waterbearer, 1986
Gelatin silver print, vinyl lettering
Photograph 45 x 77 inches (framed),
55 x 77 inches overall
Collection Sean and Mary Kelly, New York

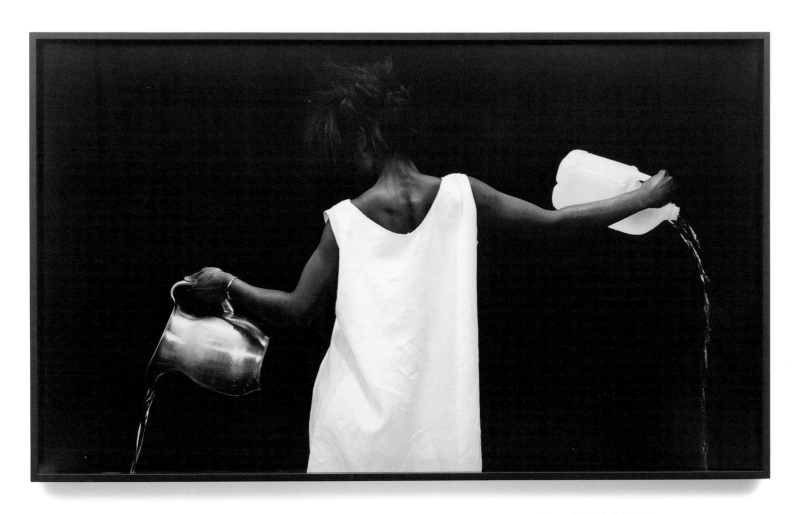

SHE SAW HIM DISAPPEAR BY THE RIVER,
THEY ASKED HER TO TELL WHAT HAPPENED,
ONLY TO DISCOUNT HER MEMORY.

MONDAY TUESDAY WEDNESDAY

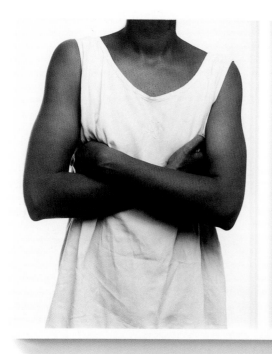 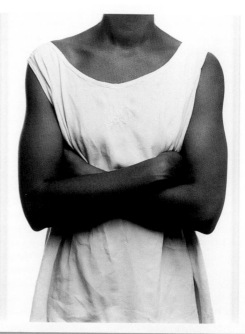 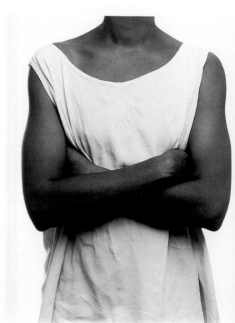

MISDESCRIPTION MISINFORMATION MISIDENTIFY MISDIAGNOSE MISFUNCTION MISTRANSCRIBE

THURSDAY

FRIDAY

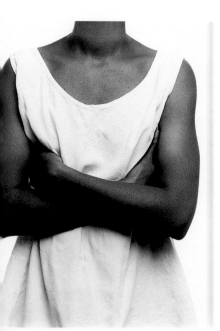
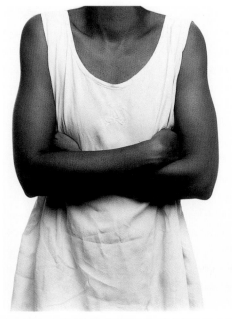

MISREMEMBER

MISGAUGE

MISCONSTRUE

MISTRANSLATE

Five Day Forecast, 1988
5 black-and-white prints, 15 engraved plastic plaques
Photographs 24 x 20 inches each, 24½ x 97 inches overall
Collection Barbara and Aaron Levine, Washington, D.C.

FOLLOWING PAGES
You're Fine, 1988
4 color Polaroid prints, 15 engraved plastic plaques,
21 ceramic pieces (19 letters, 2 apostrophes)
40 x 103 inches overall
Collections Peter Norton and Eileen Harris Norton,
Santa Monica

PHYSICAL EXAM

BLOOD TEST

HEART

REFLEXES

CHEST X-RAY

ABDOMEN

ELECTROCARDIOGRAM

URINE

LUNG CAPACITY

EYES

EARS

HEIGHT

WEIGHT

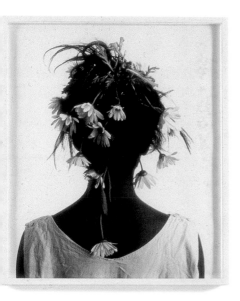
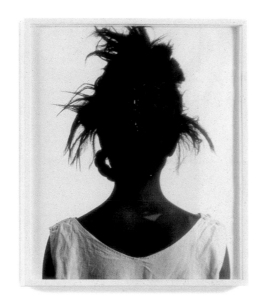

Magnetic Country Fresh Sweet

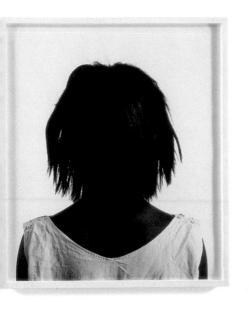
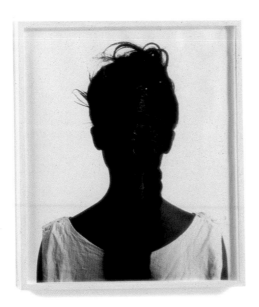

Stereo Styles, 1988
10 Polaroid prints, 10 engraved plastic plaques
Photographs 35 x 31 inches each, plaques 3 x 6
inches each, 66 x 116 inches overall
Collection Raymond Learsy and Melva
Bucksbaum, Connecticut

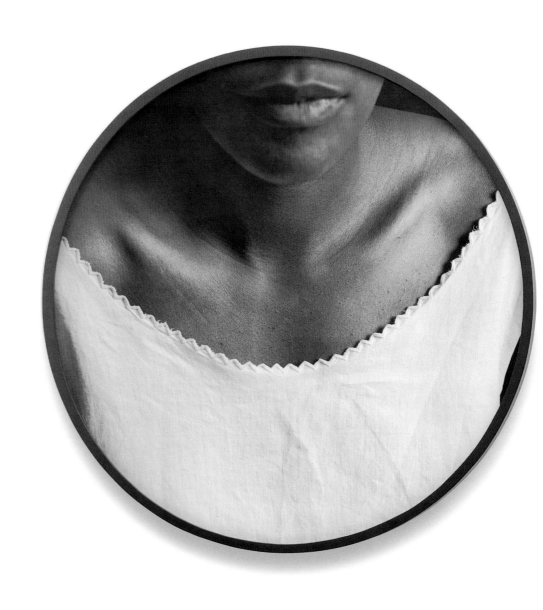

Untitled (2 Necklines), 1989
2 gelatin silver prints, 11 engraved plastic plaques
Photographs 36 inches each (diameter),
40 x 100 inches overall
National Gallery of Art, Washington;
gift of the Collectors Committee

ring

surround

lasso

noose

eye

areola

halo

cuffs

collar

loop

feel the ground
sliding from under you

Proof Reading, 1989
4 Polaroid prints, 4 engraved plastic plaques
40 x 40 inches overall
Collection Steven Johnson and Walter Sudol, New York

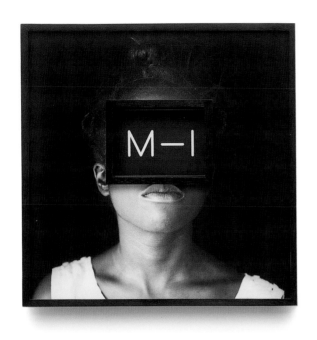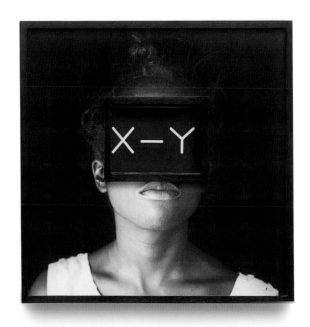

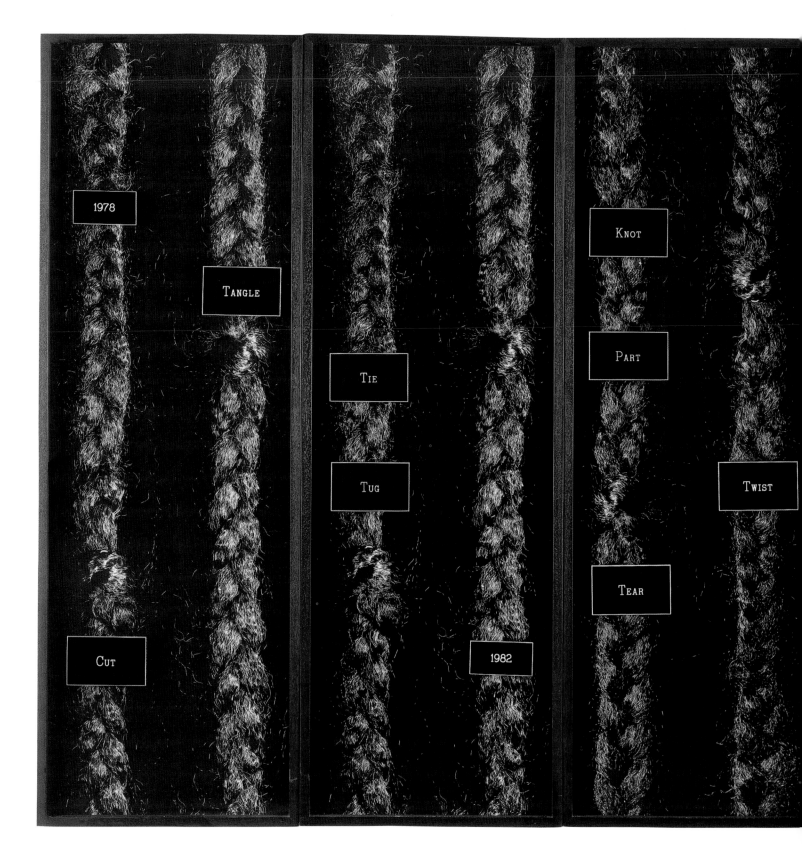

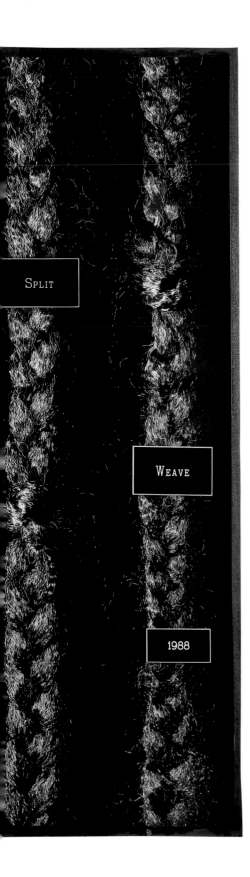

1978—88, 1990
4 gelatin silver prints, 13 engraved plastic plaques
Photographs 49 x 17 inches each (framed),
49 x 70 inches overall
Collection Gregory R. Miller, New York

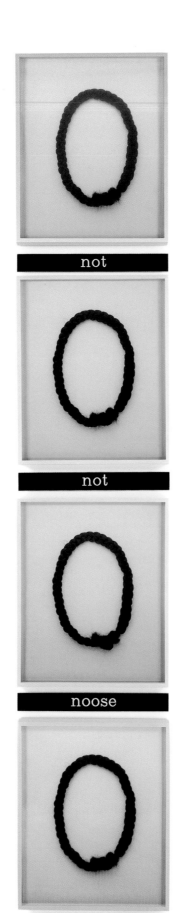

Double Negative, 1990
Dye diffusion transfer, plastic
Photographs 23⅞ x 19⅝ inches each,
113½ x 21 inches overall
High Museum of Art, Atlanta, Georgia; purchase
with funds from the National Endowment
for the Arts and Edith G. and Philip A. Rhodes
(1990.69a–g)

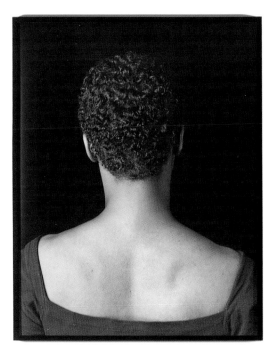 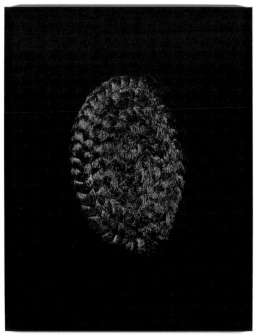

braid into four circles

over-hand
under-hand
whichever you prefer

part into eight sections
from the crown

each section is twisted anti-clockwise

a hair piece is
attached to the crown

braids meander over
entire head

a section of hair is parted
and held firmly
between left thumb & forefinger

starting just behind the ears

tips of each strand are connected
until they form a circle

the transverse braids from
a series of zig-zags

Coiffure, 1991
3 gelatin silver prints, 10 engraved plastic plaques
Photographs 47 x 39 inches each, 72 x 106 inches overall
Collection Michael Krichman and Carmen Cuenca, San Diego

Figure, 1991
Gelatin silver print, 8 engraved plastic plaques
Photograph 75 x 43⅛ inches (framed),
75 x 82½ inches overall
Ellipse Foundation-Contemporary Art Collection,
Amsterdam

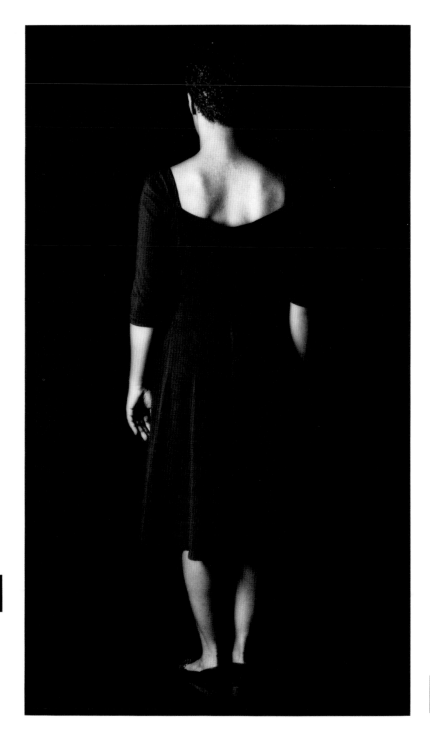

figured the worst

figured on all the times there
was no camera

he was disfigured

figured there
would be no reaction

figured legality had nothing
to do with it

figured she was suspect

figured he was suspect

figured someone had been there
because the door was open

Biopsy Biography

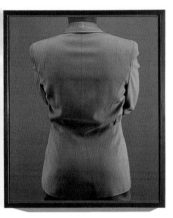
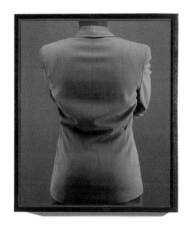

Biology

Bio, 1992
18 Polaroid prints, 9 engraved plastic plaques
98 x 162 inches overall
Museum of Contemporary Art, Chicago;
gift of Maremont Corporation by
exchange, purchased through funds provided
by AT&T New Art/New Vision (1992.90.a–u)

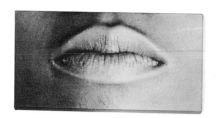

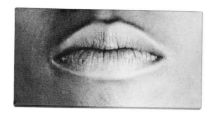

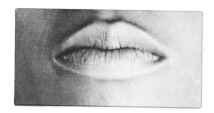

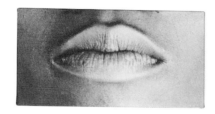

7 Mouths, 1993
7 photo-linen panels
61 x 16 inches overall
Collections Peter Norton and Eileen Harris Norton,
Santa Monica

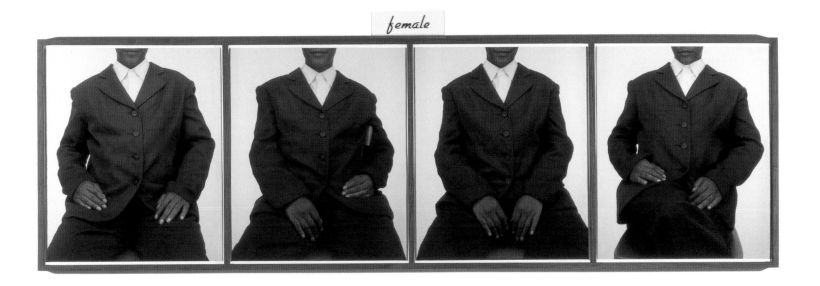

female

She, 1992
4 Polaroid prints, 1 engraved plastic plaque
29 x 85¼ inches overall
Collection Jack and Sandra Guthman, Chicago

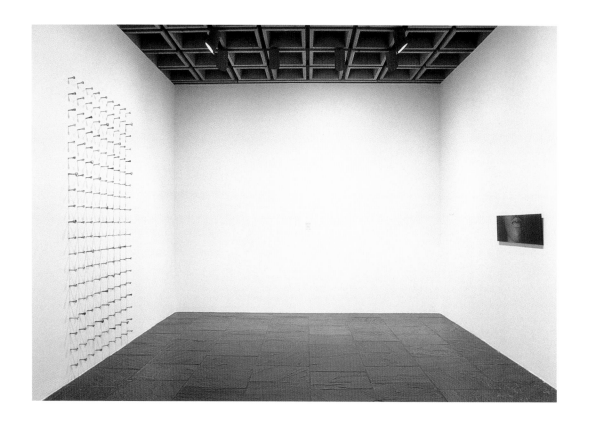

ABOVE AND RIGHT DETAIL

Hypothetical? 1992
Photograph, text, instrument mouthpieces, sound
Dimensions variable
Collection Emily Fisher Landau, New York
(Amart Investments LLC)

FOLLOWING PAGES

Wigs, 1994
50 waterless lithographs on felt
98 x 265 inches overall
Des Moines Art Center Permanent Collections;
purchased with funds from the Edmundson
Art Foundation, Inc. (1995.4)

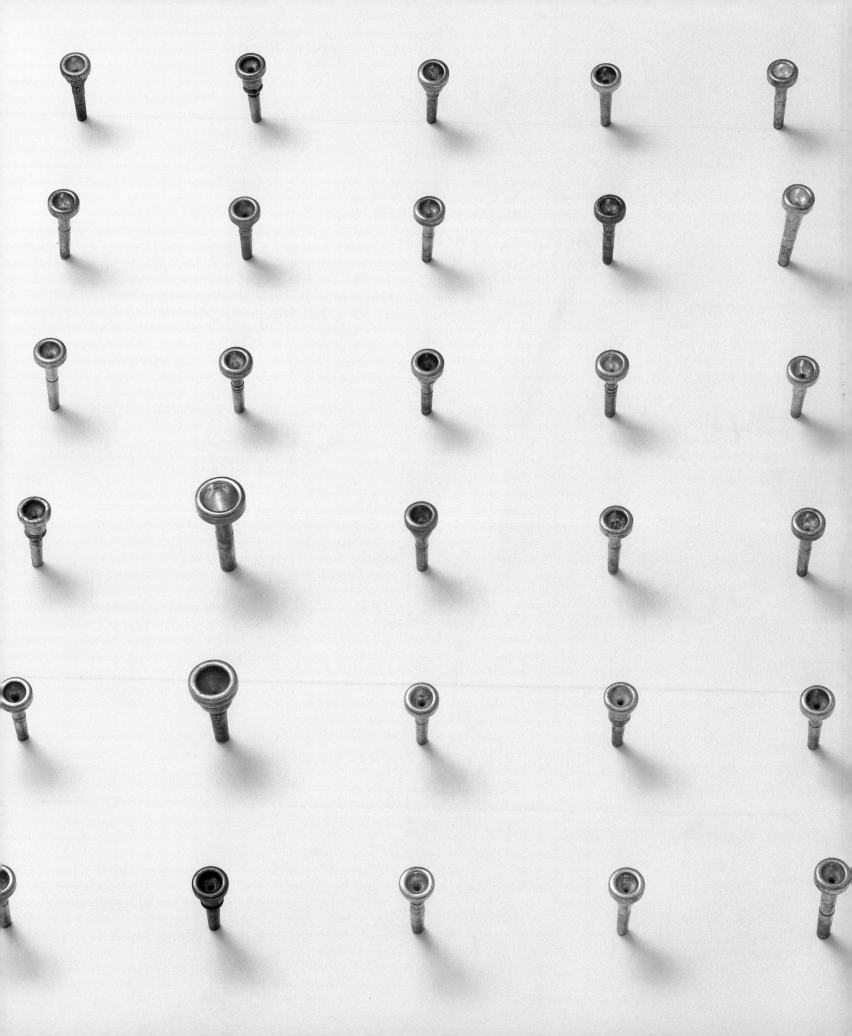

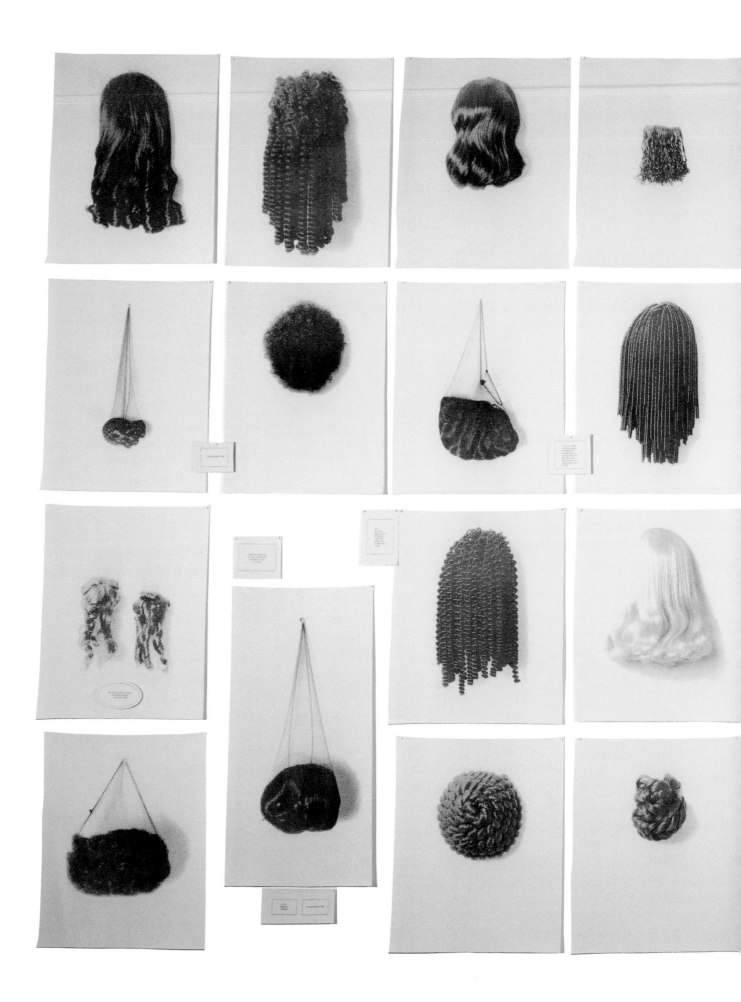

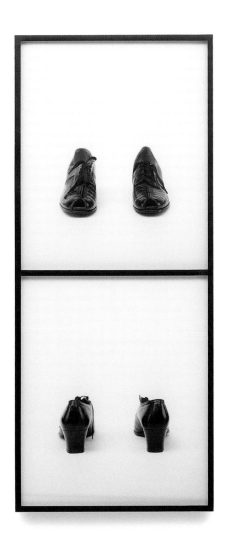

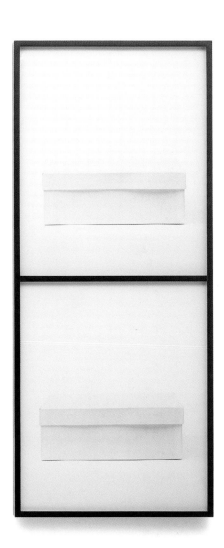

at her burial
I stood under
the tree next
to her grave

when I returned
the tree was a
distance from her
marker

Young Anthony,
1926
James VanDerZee
Artist (fl.1920). Wearing a formal coat, he is seated with
his right leg crossed and holds it with his right hand. To his
left is a small table with a circular top and a vase with
Chrysanthemums. A window folding screen stands behind him.

Hero of the Ball,
1926
James VanDerZee
S/he is dressed in a shirt and small jacket with ball sleeves. The neck, sleeves
and bottom of the skirt is trimmed in fur, and her/his silk stocking legs and with and satin shoes are
crossed at the table. She/he is seated and rests her/his left elbow on the table, and her/his right hand
on her/his lap. A painted backdrop of a window and a landscape appears behind her/him. A vase
with flowers and a photo are on the table.

Woman with a goldfish bowl,
1923
James Van Der Zee
A woman wearing pearls stands behind a bouquet of flowers and goldfish bowl.
Her right hand rests on the rim of the bowl, as she gazes at a painted
image of a butterfly in flight.

Evening Suit,
Adolphdresser
James VanDerZee
A striking a pose rests her face on her right arm as her left arm
rests on her breast. Fabric is draped over the edge of the circle,
around her hips and comes to the floor. Her legs are exposed
knees bent, and her left foot is tucked under her right. Flowers
are thrown over the edge of the couch and on to the floor. An
upside down vase sits on the floor, as if in position and the
arrangement of flowers had been disturbed.

Dinner Party with beer drinking folks,
1926
James VanDerZee
Harry Wills aka "The Black Panther." Jesus, Amateur,inner sits with
seven other men and woman, mostly women with champagne glasses raised in a
toast as he left makes a toast at his tummy. There are three bottles of champagne,
a crystal decanter, a bottle of port, an arrangement of flowers and fruit, and below
each guest an untouched china place setting.

A man in his bedroom,
1925
James VanDerZee
A man stands on the far left of the room with a pipe in his mouth. He is dressed in a smoking jacket
with a shirt and tie, with his right elbow resting on a dresser and a ring on his finger. The first has a
satin crown with a small slatted animal positioned in the center in the pillows. Behind the bed hangs a
rug, off of the backboard a hinged lamp, and above hangs an chandelier. In front of a curtained window
a standing lamp shines on the portrait of a full figured woman. On the right side of the room is a
dresser with an ashtray, small boxes, a candle and vase.

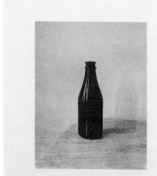

Just After the Battle,
1920s
James VanDerZee
Calendar image for the Elks Convention taken in an apartment on 135th street. A woman is wearing a
kimono is seated in a rocking chair with a cigarette in her left hand and a ceiling gas in her right, with
legs crossed. A hinged lamp positioned behind her lights her face. Hand painted smoke, trails from
the tip of the cigarette. A chair's back is mounted on the wall with two framed images of figures
bathing, a floral design and a mirror at the center of the arrangement. At her feet are an array of
objects - three nude bottles, crossed cups and saucers stacked, and four vases. "Her husband would go
berserk that night late, and if his explanation wasn't satisfactory, well, the had all that ammunition
there to blast him with."

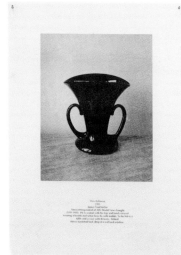

The Ballroom,
1925
James VanDerZee
News coming product at Mr. Woodof News Tonight.
(1925-1950). He is seated with his legs and hands crossed
wearing a tuxedo and white bow tie with buckle. To his left is a
table and a vase with flowers. Behind
him is a painted back drop of a wall and window.

Tea time at Madame C.J. Walker's Beauty Salon,
1929
James VanDerZee
Sarah Breedlove Walker (1864-1919), developed a hair care product that
was very successful, and set up the Walker Manufacturing Company in Indianapolis as well as the
Walker College of Hair Culture in Harlem. Six elmos elegantly dressed women appear seated and
standing, seven are holding tea cups.

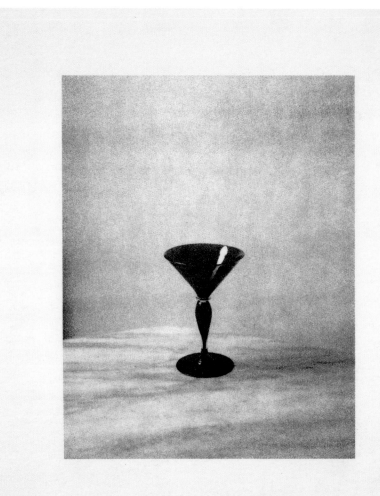

Dinner Party with boxer Harry Wills,
1926
James VanDerZee
Harry Wills aka "The Black Panther," boxer, businessman- sits with
seven other men and women, mostly women with champagne glasses raised as a
woman on his left makes a toast in his honor. There are three bottles of champagne,
a crystal decanter, a bottle of port, an arrangement of flowers and fruit, and before
each guest an untouched china place setting.

Max Robinson,
1981
James VanDerZee
News correspondent of ABC World News Tonight
(1939-1988). He is seated with his legs and hands crossed
wearing a tuxedo and white bow tie with medals. To his left is a
table and a vase with flowers. Behind
him is a painted back drop of a wall and window.

The Clock Tower, 1995
Serigraph on 12 felt panels with 1 text panel
100½ x 90 inches overall
Collection Mr. and Mrs. Michael Ringier, Zurich

*He can hear sighs and conversations of people
collecting in the hall waiting for elevators,
heading out of the building, the telephone rings.*
"Good, I hoped that you were still here."
"Yeah, well I thought that it might be you."
"Where do you want to meet?"
*"Well, they are still under construction on the
15th floor and the union guys are out of there by
now and I think they have finished a few
of the offices with good views. Wait a second...
I don't hear the muffled power tools. Want
to go there?"*
"Sure, I have not been down there as yet."
*"What about the rooftop conference room? Was
there anything scheduled there today?"*
*"I don't think so, but we will have to take
the stairs to get up there...the west staircase is
always an option a little later if you still have
work to do."*
"Naw, I'm almost finished."
"What time do you have?"
"8:20."
"I'll meet you in the hall at a quarter to."
"Okay."

50

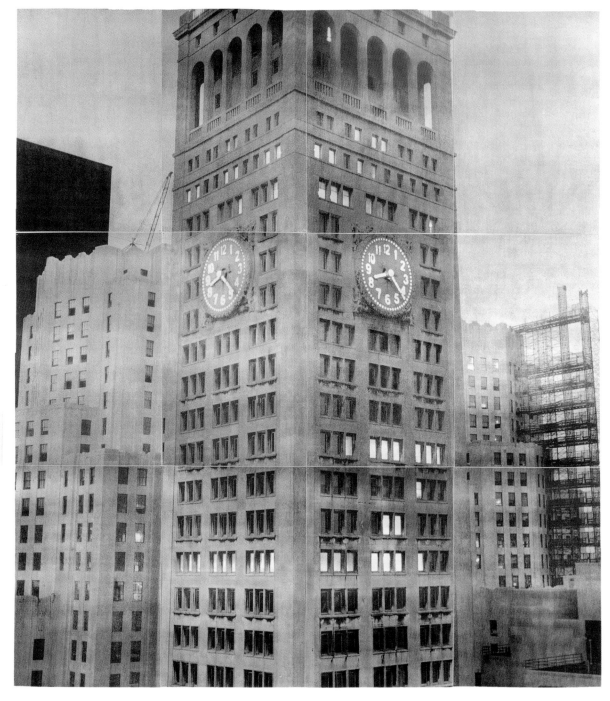

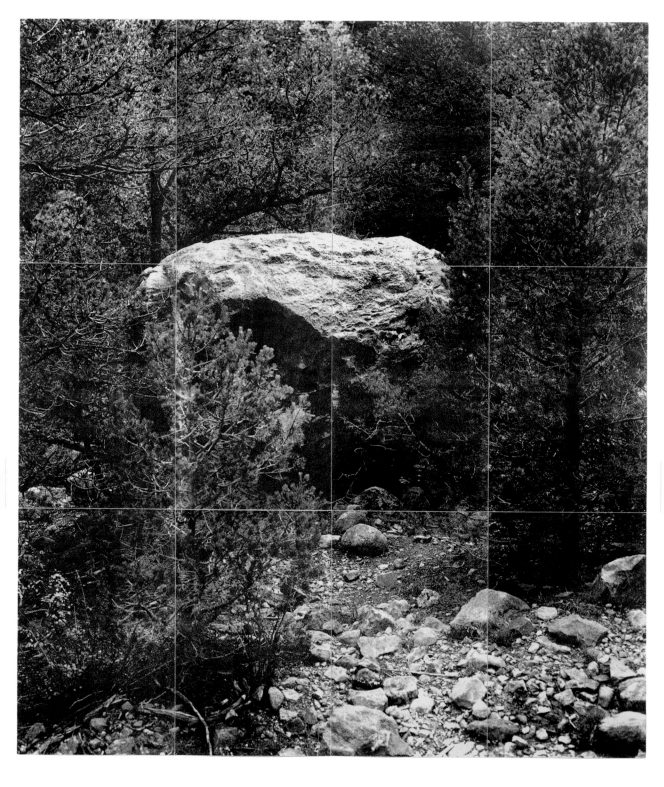

The Rock, 1995
Serigraph on 12 felt panels with 2 felt text panels
100½ x 89½ inches overall
Courtesy the artist and Sean Kelly
Gallery, New York

Female Trouble: Divine has just left home after an argument over a Christmas gift, and storms out of the house. She is picked up on the highway by an auto-mechanic (played by Divine). They approach a wooded area and have frantic sex on a mattress, by the side of the road.

Driving all day long, has induced a hypnotic state upon both of us. It is definitely time to pull over. I recognize the state park that we are now in the middle of, and can endure a few more minutes of this drive in order to find the same spot I went to last time I was here. Hoping that this search will not turn into another journey, since I didn't make any mental notes of the surroundings during my last visit, I'm ill prepared, and not really wanting to appear too familiar with the area. I make an effort this time to commit this trip to memory. But here we are, sick of driving. We get out of the car and start to hike to find a spot and it will probably replace the last one, completely. Haven't seen any weekend hikers for a while and since we are miles away from any rest stops it seems plausible that we will not be patrolled. I asked, "How's this?" "Is it secluded enough for you?"

The Park, 1995
Serigraph on 6 felt panels with 2 felt text panels
67 x 67½ inches overall
Collection Emily Fisher Landau, New York
(Amart Investments LLC)

*Just unpacked a new shiny silver
telescope. And we are up high enough for
a really good view of all the buildings
and the park. The living room window
seems to be the best spot for it.
On the sidewalk below a man watches
figures from across the path.*

*It is early evening, the lone sociologist walks
through the park, to observe private acts
in the men's public bathrooms. These facilities
are men's and women's rooms back to back.
He focuses on the layout of the men's
bathroom— right to left: basin, urinal, urinal,
urinal, stall, stall. He decides to adopt
the role of voyeur and look out in order to go
unnoticed and noticed at the same time.
His research takes several years. He names his
subjects A, B, C, X, Y, and O, records their
activities for now, and their license plates when
applicable for later.*

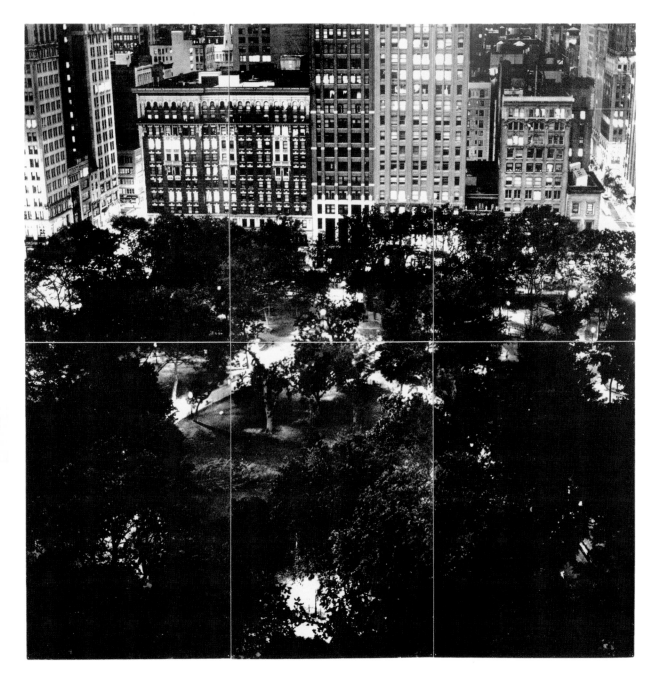

LEFT AND FOLLOWING PAGE DETAIL
Details, 1996
21 photogravures with text
10 x 8 inches each, installation variable
Collections Peter Norton and Eileen Harris Norton,
Santa Monica

57

detail of **Details**

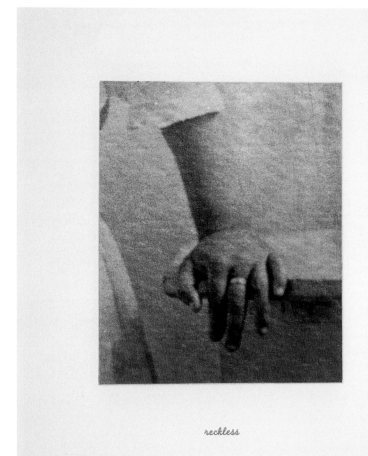

reckless

carried a gun

in love and tried to stay out of trouble

NO. 1 Makes a call, 11:45 am

NO. 2 Waiting to make a call, 11:58 am

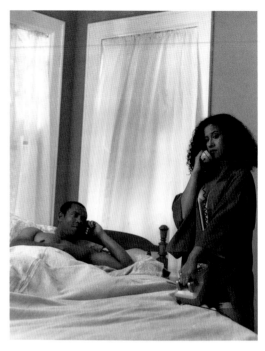

NO. 3 Separate lines, 12:05 pm

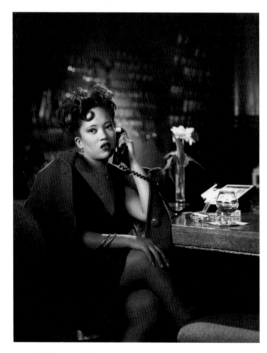

NO. 7 Taking a call, 4:35 pm

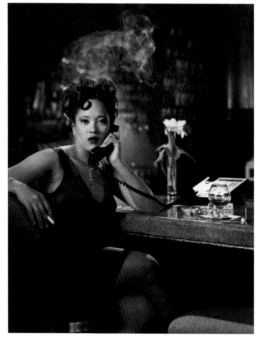

NO. 8 Listening to a message, 4:40 pm

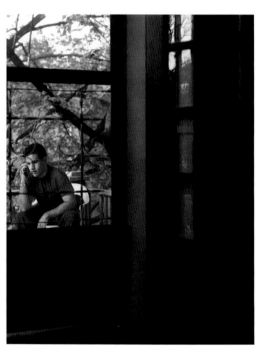

NO. 9 Call on the other line, 4:47 pm

Call Waiting, 1997
12 silver gelatin prints with silk-screened texts
20 x 16 inches each
From the video installation **Call Waiting**, 1997
16mm black-and-white film transferred to DVD
13 minutes, 11 seconds, sound
Commissioned for inSite '97
Courtesy the artist and Sean Kelly Gallery,
New York

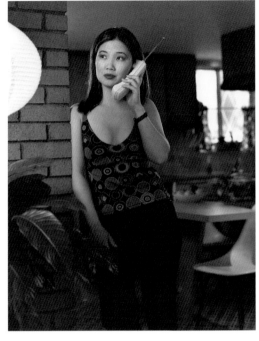

NO. 4 Message, 4:15 pm

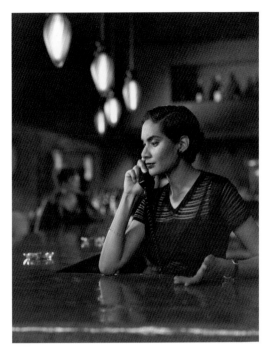

NO. 5 Call at work, 4:29 pm

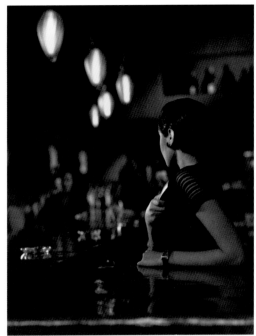

NO. 6 Call for her, 4:33 pm

NO. 10 3-way call, 4:50 pm

NO. 11 Returning a call, 5:00 pm

NO. 12 Letting it ring, 5:07 pm

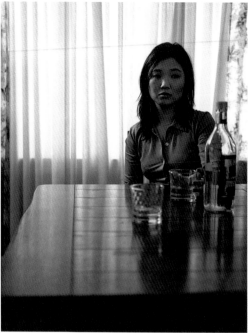

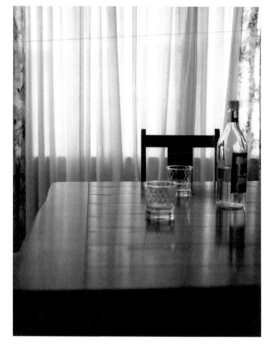

No. 1 ...at the moment she could not, although she said she would–disappointed in her inability to carry through her plan, her friend changes the subject.

No. 2 ...distracted, her mind wanders–how many people can one contemplate killing? She weighs her options and contemplates what to do next.

No. 3 ...they leave the house

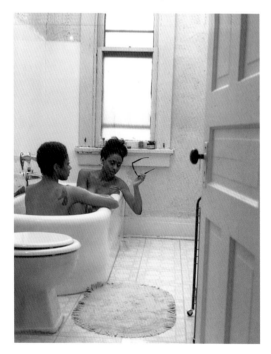

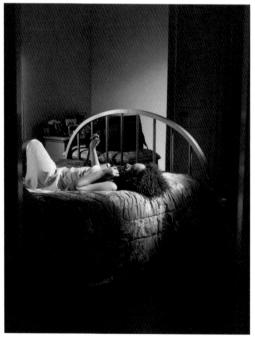

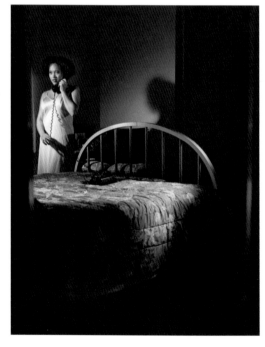

No. 10 ...patterns of visibility from the stage

No. 11 ...soft, yet deliberate and convincing, "uh huh, uh huh…"

No. 12 ...soft, yet deliberate and convincing, "I'm not going anywhere–sure I'll be here"

Interior/Exterior, Full/Empty, 1997
18 gelatin silver prints with silk-screened texts
20 x 16 inches each
Courtesy the artist and Sean Kelly Gallery, New York
From the video installation **Interior/Exterior, Full/Empty**, 1997
7-channel DVD projection of 16mm black-and-white film
20 minutes, sound
Commissioned by the Wexner Center for the Arts
at the Ohio State University
Courtesy the artist and Sean Kelly Gallery, New York

Still, 1997
Serigraph on 36 felt panels with 1 text panel
120 x 216 inches overall
Miami Art Museum; museum purchase with funds
from Mark and Nedra Oren and an anonymous
donor (1997.1a–kk)

The Staircase, 1998
Serigraph on 6 felt panels with 1 felt text panel
66 x 66 inches overall
Collection Mark and Nedra Oren, Miami

TEXT PANEL

*Her apartment was on the ground floor, which
meant she was in earshot of footsteps and
conversations. As the climbers or climber
reached the 10th step, there was a break in the
rhythm of the climbing, because its riser was
slightly lower than the rest. From her apartment
it sounded as though they had tripped,
especially those who were unfamiliar with this
inconsistency. She could hear the warnings
offered by tenants as they guided their guests
to their floor; particularly when they were
assisted in carrying something; the apologies
when they had forgotten to mention it in
time; or the conversations that took place in
midstream, that indicated the level of
familiarity between climbers. There were some
other sounds, not too long ago that seemed
to be coming from the landing below. They were
faint and unrecognizable. It did not sound
like talking, but more like the rhythmic lifting
of a heavy object.*

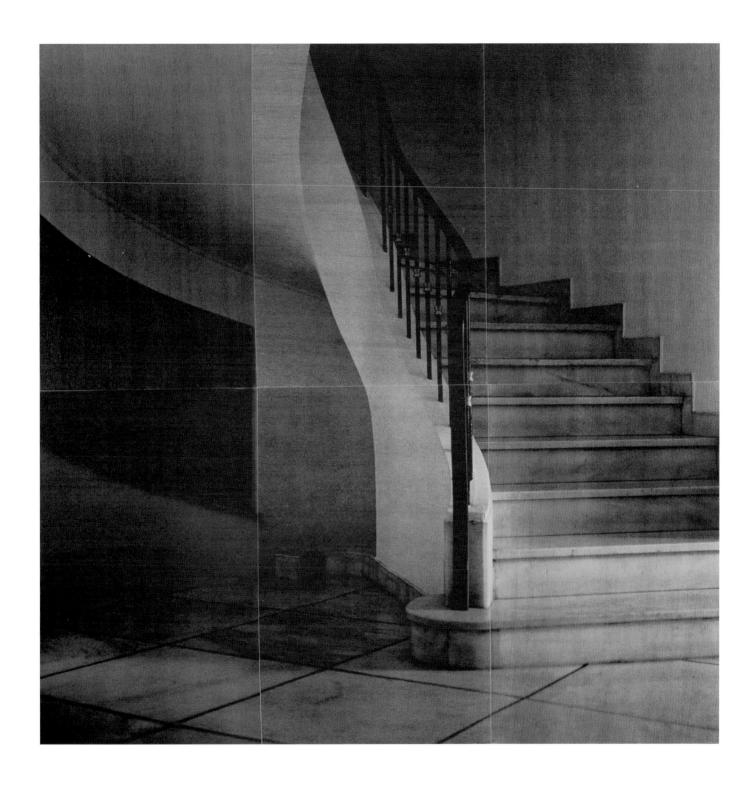

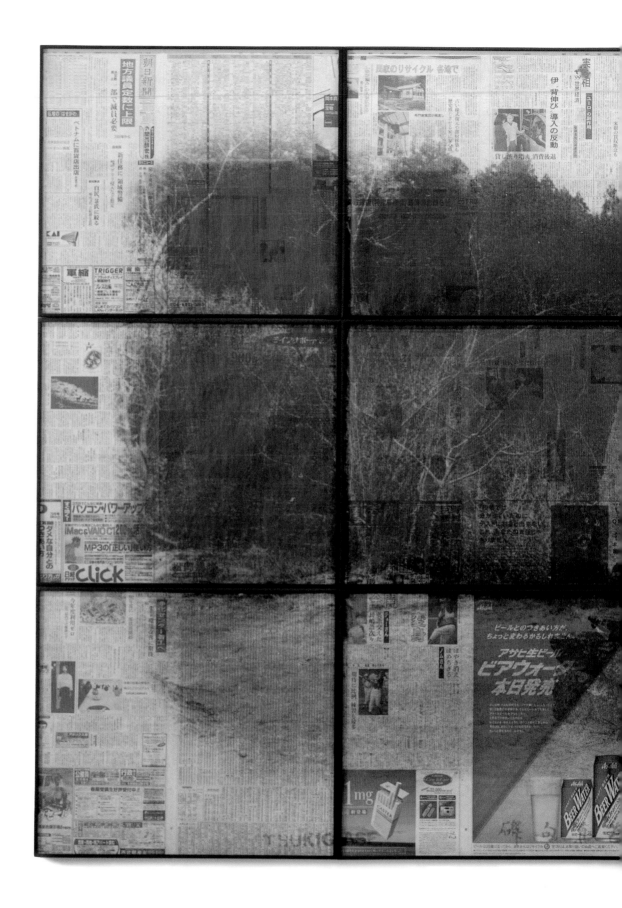

Rock/Haiku, 1999
Set of 12 framed sheets
of silk-screened Japanese newsprint
73 x 84 inches overall
Courtesy the artist and Sean Kelly
Gallery, New York

70

Night, 1999
Set of 12 framed sheets of
silk-screened Japanese newsprint
63 x 102¾ inches overall
Collection Mr. and Mrs. Michael Ringier, Zurich

detail of **Night**

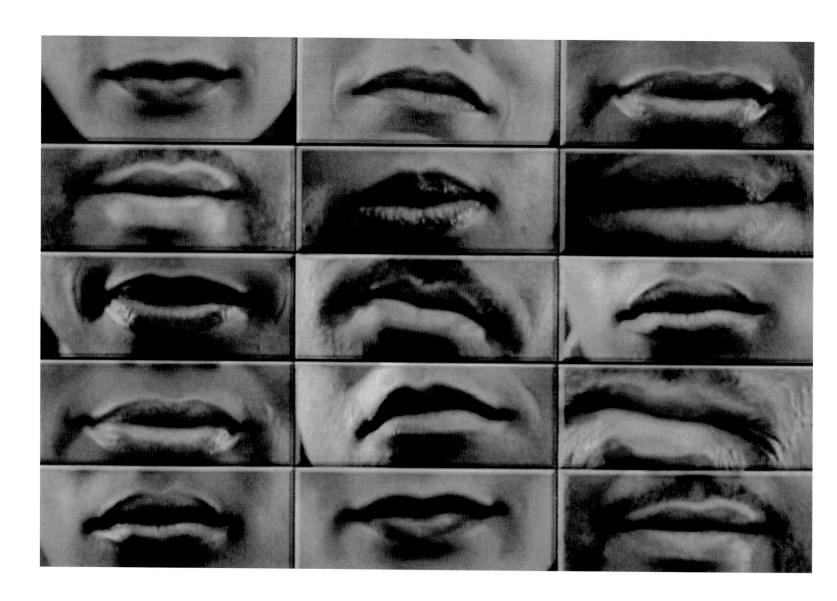

from **Easy to Remember**, 2001
Video installation, 16mm black-and-white
film transferred to DVD
2 minutes, 35 seconds, sound
Denver Art Museum; funds from Peter Norton Family
Foundation, Cathey and Richard Finlon,
and department acquisition funds (2002.89)

**Untitled (guess who's coming
to dinner)**, 2001
Gelatin silver prints under semi-
transparent Plexiglas with vinyl lettering
61 x 41 inches
Courtesy the artist and Sean Kelly
Gallery, New York

FOLLOWING PAGES
**Untitled (melancholy dame/
carmen jones)**, 2001
Gelatin silver prints under semitransparent
Plexiglas with vinyl lettering
Diptych, 18½ x 40 inches overall
Collection Joel and Anne Ehrenkrantz, New York

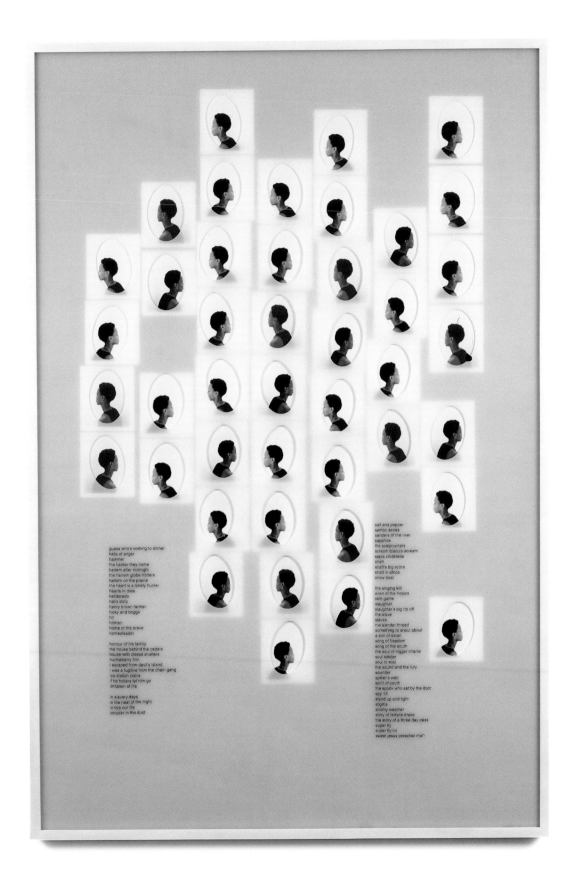

guess who's coming to dinner
halls of anger
hammer
the harder they come
harlem after midnight
the harlem globe trotters
harlem on the prairie
the heart is a lonely hunter
hearts in dixie
helldorado
hallo dolly
henry brown farmer
hicky and boggs
hit
hitman
home of the brave
homesteader

honour of his family
the house behind the cedars
house with closed shutters
huckleberry finn
i escaped from devil's island
i was a fugitive from the chain gang
ice station zebra
if he hollers let him go
imitation of life

in slavery days
in the heat of the night
in this our life
intruder in the dust

salt and pepper
sambo series
sanders of the river
sapphire
the scalphunters
scream blacula scream
sepia cinderella
shaft
shaft's big score
shaft in africa
show boat

the singing kid
siren of the tropics
skin game
slaughter
slaughter's big rip off
the slave
slaves
the slender thread
something to shout about
a son of satan
song of freedom
song of the south
the soul of nigger charlie
soul soldier
soul to soul
the sound and the fury
sounder
spider's web
spirit of youth
the spook who sat by the door
spy 13
stand up and fight
stigma
stormy weather
story of temple drake
the story of a three day pass
super fly
super fly tnt
sweet jesus preacher man

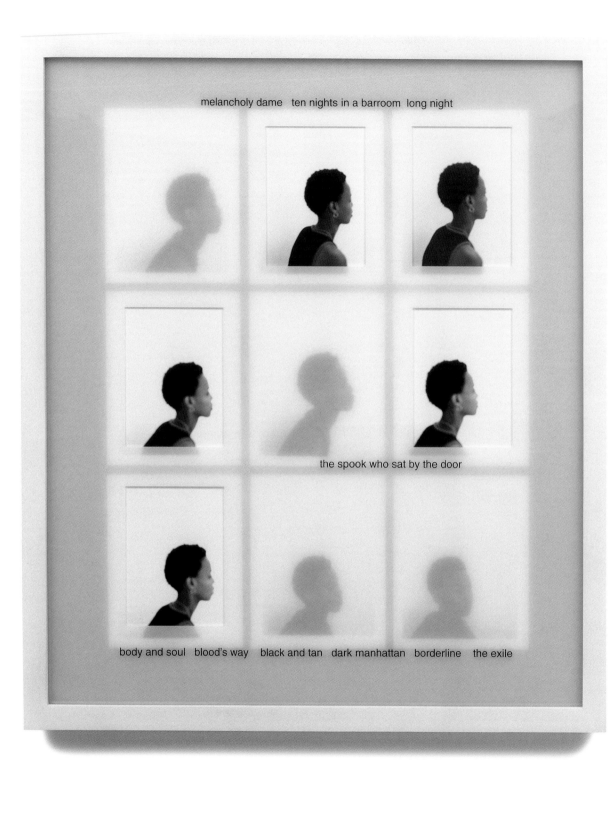

carmen jones emperor jones jezebel scream blacula scream

an affair of the skin the birth of a nation birth of the blues black caesar black waters
five on the black hand side the great white hope i was a fugitive from the chain gang

Men, 2002
Gelatin silver prints under semitransparent
Plexiglas with vinyl lettering
8 photographs, 3 text panels
24 x 65½ inches overall
Courtesy the artist and Sean Kelly Gallery, New York

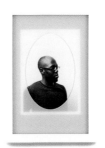
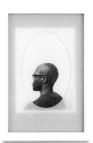
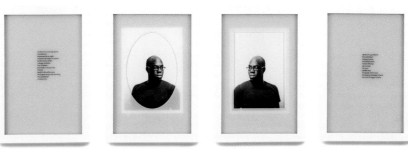

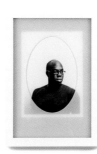

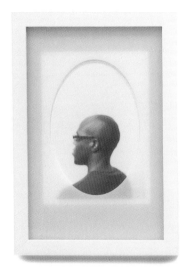 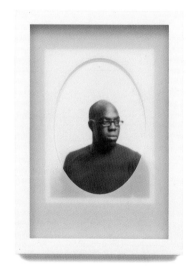

Study, 2002
Four gelatin silver prints under semi-
transparent Plexiglas with engraved lettering
12⅛ x 37½ inches overall
Courtesy the artist and Sean Kelly Gallery, New York

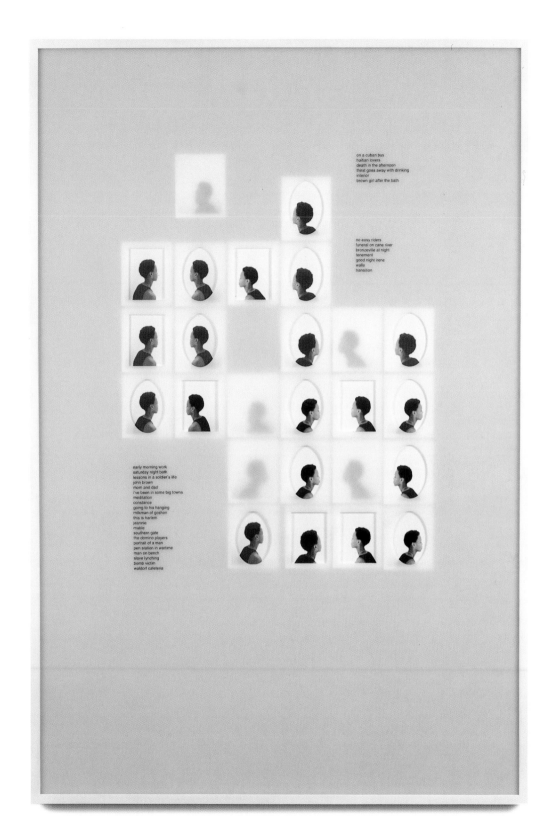

Untitled (on a cuban bus), 2001
Gelatin silver prints under semitransparent
Plexiglas with vinyl lettering
61 x 41 inches
Courtesy the artist and Sean Kelly
Gallery, New York

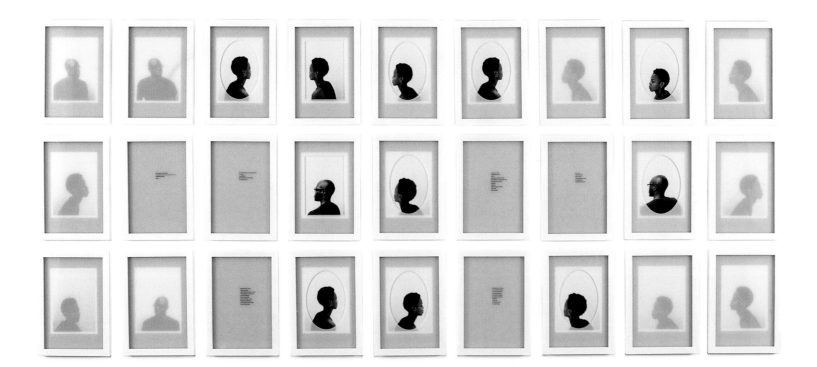

Film, 2002
Gelatin silver prints under semitransparent
Plexiglas with vinyl lettering
21 photographs, 6 text panels
38 x 84½ inches overall
Courtesy the artist

FRAMED TEXT PANELS

jim comes to jo'burg
float like a butterfly, sting like a bee
willie dynamite
shaft

the spook who sat by the door
superfly
superfly tnt
they call me mister tibbs
to sir with love

daughter of congo
siren of the tropics
for the love of ivy
georgia georgia
girl from chicago
goodbye my lady
jezebel
melinda

mildred pierce
the lost lady

the man
the lost man
native son
nothing but a man
trouble man
watermelon man

gone are the days
night and day
night of the quarter moon
odds against tomorrow
stormy weather
finian's rainbow
gone with the wind
the green pastures
in the heat of the night
the learning tree

carmen jones
cleopatra jones
coffy
daughter of the congo

free white and twenty-one
good bye my lady
jezebel
joanna
lady sings the blues
lost lady
lydia bailey

from **31**, 2002
31-channel video installation, video
transferred to DVD
20 minutes, color, sound
Dimensions variable
Courtesy the artist and Sean Kelly
Gallery, New York

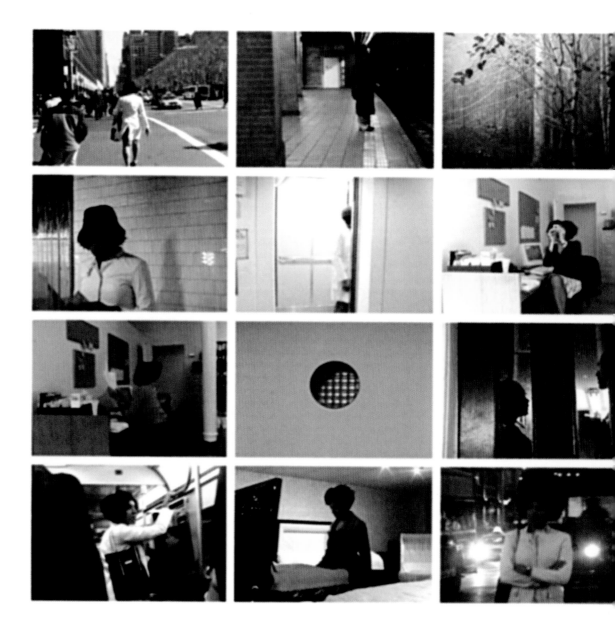

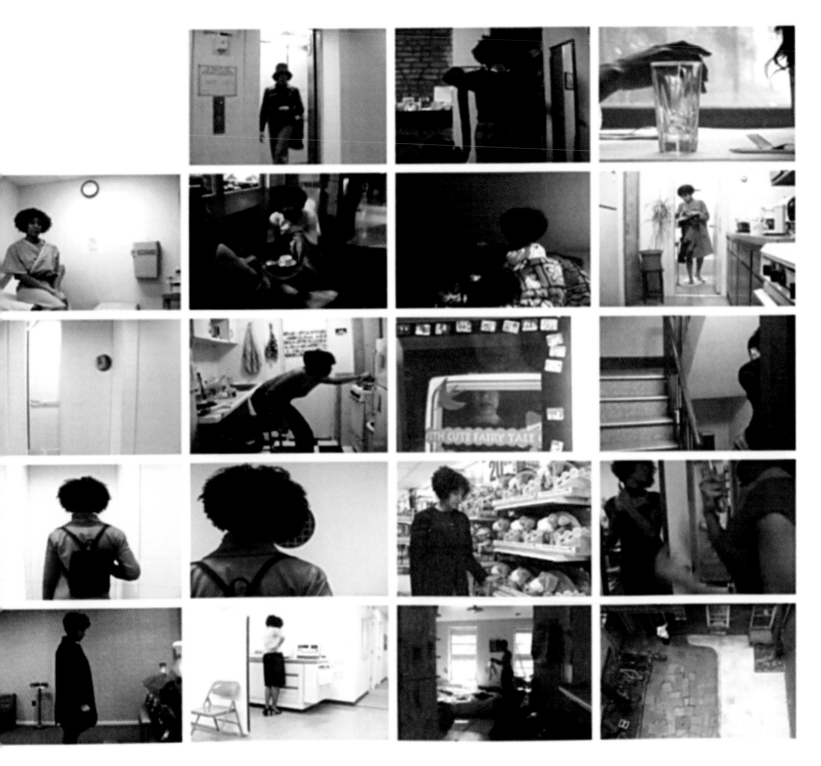

FOLLOWING PAGES

from **Corridor**, 2003
Double-projection video installation, video
transferred to DVD
13 minutes, 45 seconds, sound
Courtesy the artist and Sean Kelly Gallery,
New York

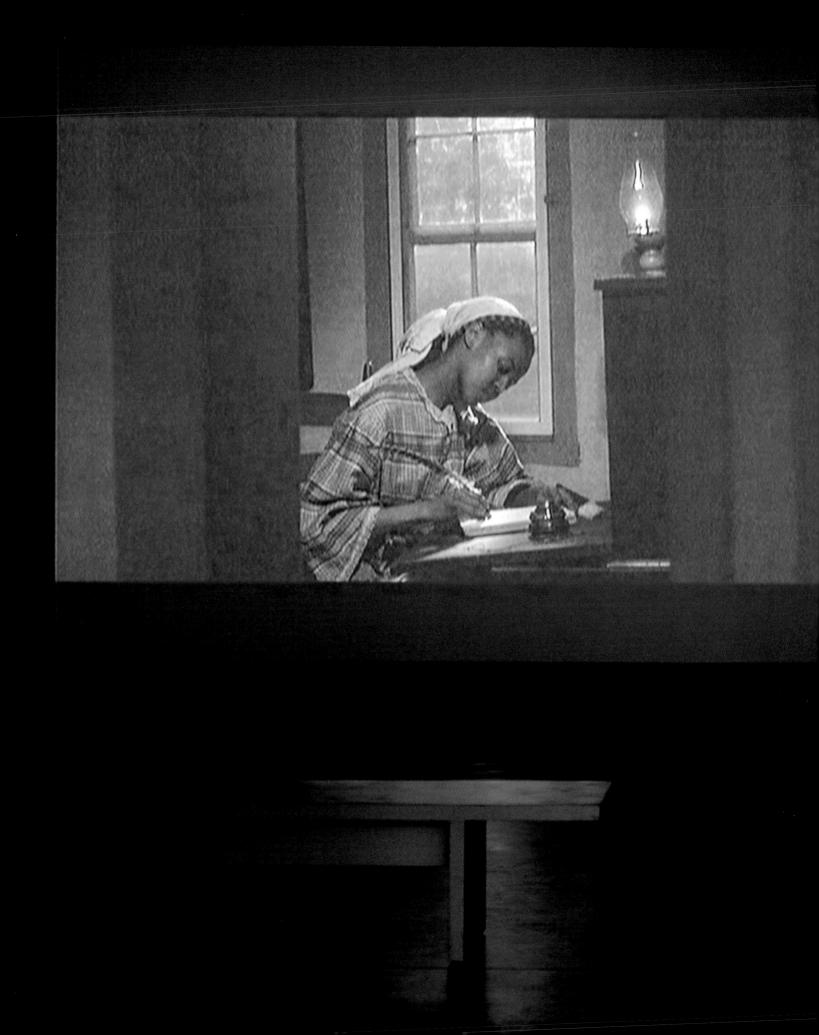

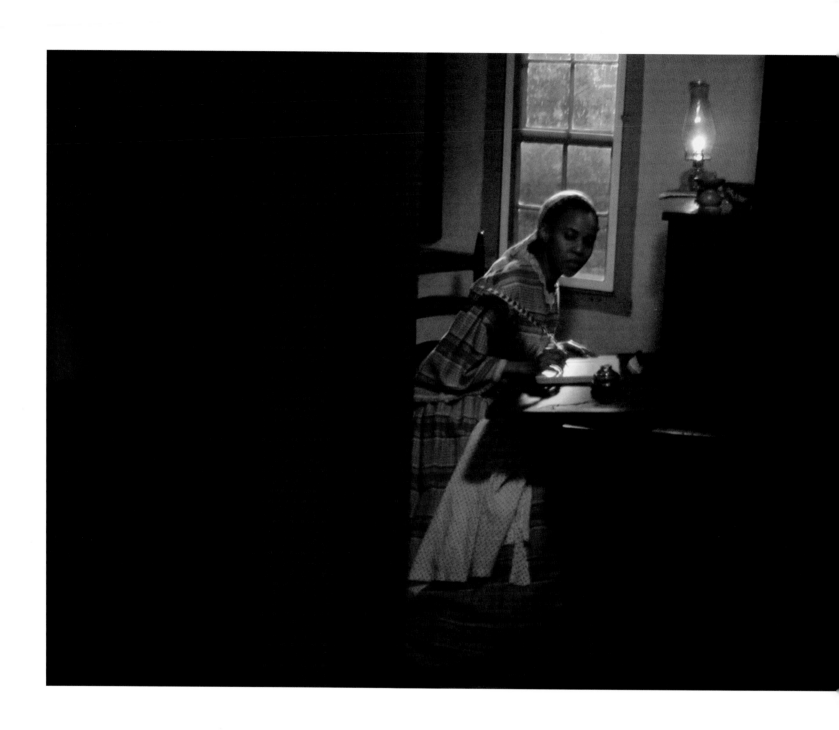

Corridor (Night III), 2003
Digital chromatic print mounted to Plexiglas
27 x 72 inches
Courtesy the artist and Sean Kelly
Gallery, New York

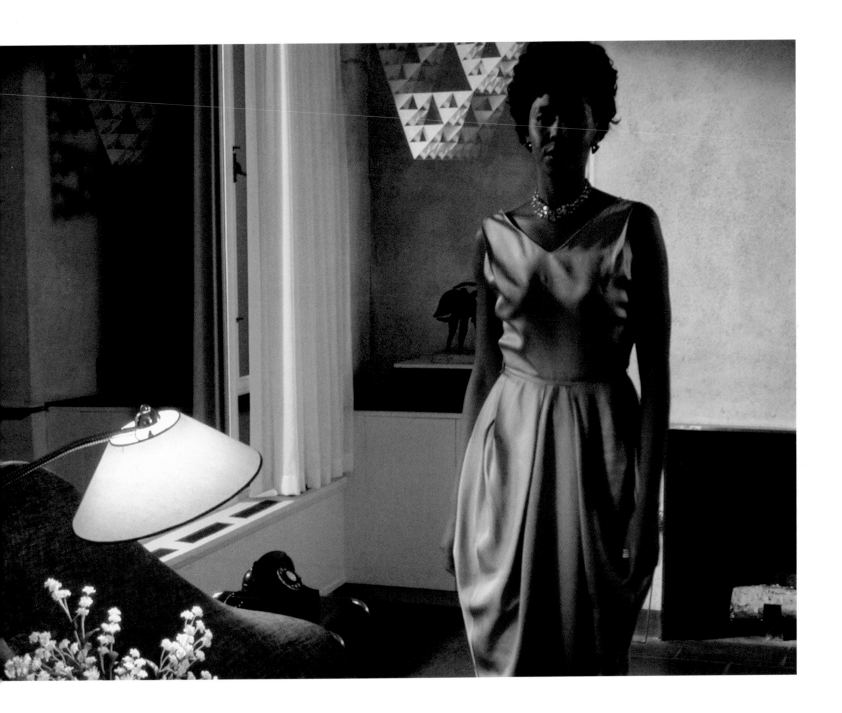

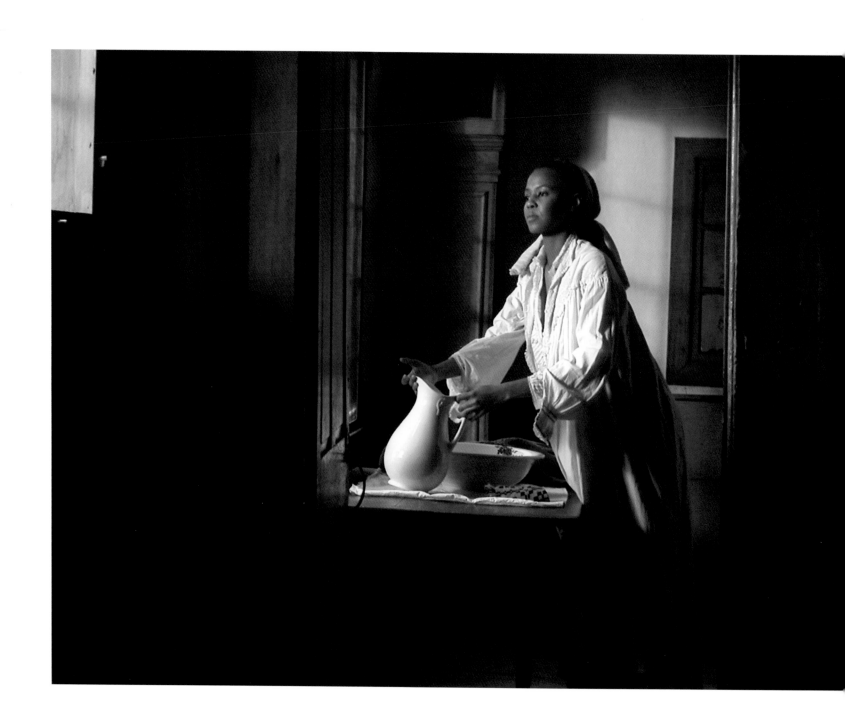

Corridor (Mirror), 2003
Digital chromatic print mounted to Plexiglas
27 x 72 inches
Collection Heidi and Erik Murkoff, Los Angeles

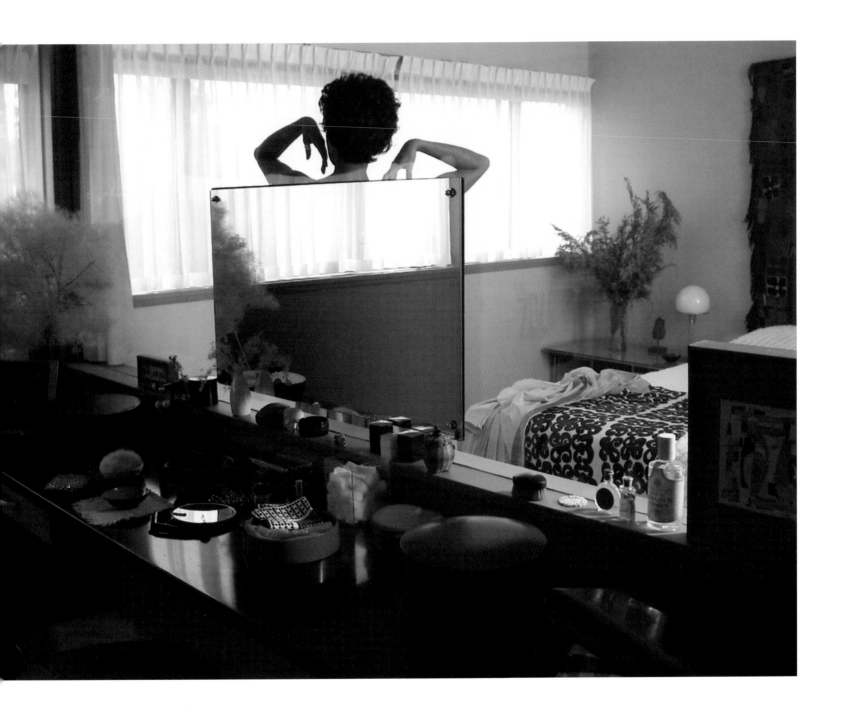

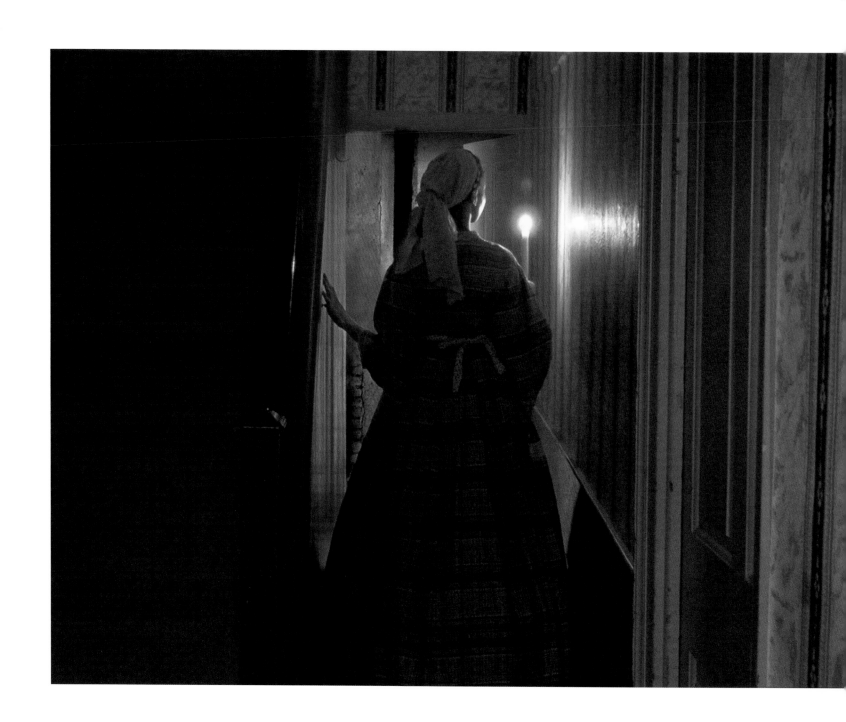

Corridor (Phone), 2003
Digital chromatic print mounted to Plexiglas
27 x 72 inches
Courtesy the artist and Sean Kelly
Gallery, New York

96

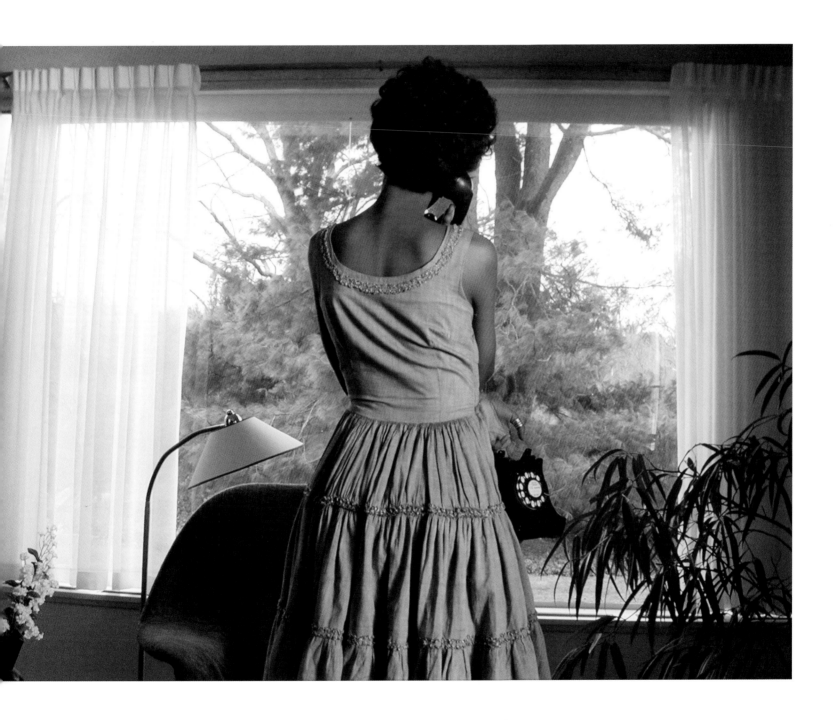

Cloud, 2005
Serigraph on 9 felt panels
84 x 84 inches overall
Courtesy the artist and Sean Kelly Gallery,
New York

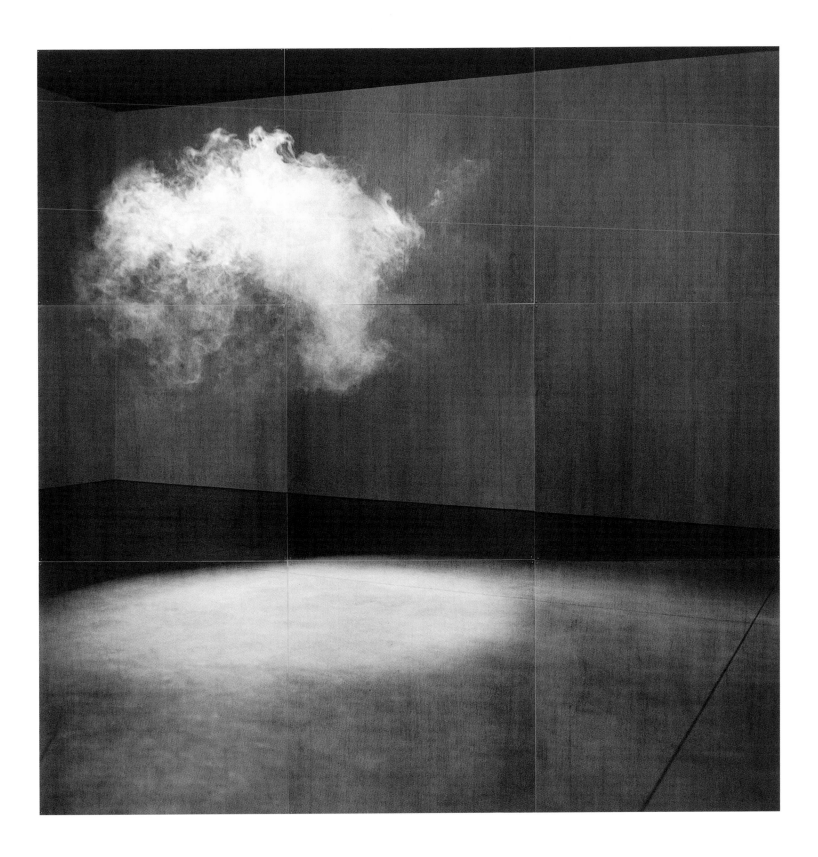

from **Cloudscape**, 2004
Single-projection video installation,
video transferred to DVD
3 minutes, sound
Courtesy the artist and Sean Kelly
Gallery, New York

repetition and differentiation— lorna simpson's iconography of the racial sublime

OKWUI ENWEZOR

...fundamentally, the camera is merely a subjective apparatus, an apparatus of subjectivity. I would go so far as to say that the camera is a wholly philosophical product; it is an instrument of cogito.
—Georges Didi-Huberman[1]

bEGINNINGS

In the late 1970s, Lorna Simpson embarked on a trip of discovery: the discovery of photography to which she has devoted a quarter century of her illustrious artistic career. At the same time there was a parallel journey, closely allied with the first, based on an extended series of travels to Europe, Africa, the Caribbean, and the United States, where she began employing the camera to document her passage through territories that were then just beginning to register their diverse cultural and spatial settings in her pictorial imagery. These two coordinated trips over several summers—across continents, communities, and cultures—give the first indications of Simpson's preternaturally clear artistic motivation. What is immediately striking in the images generated from these trips is not the furtive tentativeness of an amateur. Instead, her photographs exhibit a sense of great visual control and a directness that is neither too intimate nor surreptitious. There is a hint of diffidence that one senses in the photographs, as if she were working around the edges of her subjects. By the same token, the images are utterly devoid of cant and sentimentality. In this clutch of photographic images that form the earliest public manifestation of her practice,[2] the ground was laid for what ultimately became the basis of a photographic argument about the nature of photographic subjectivity and the artist's control over the process of image making. In Italy, Spain, France, Morocco, Mauritania, Algeria, Jamaica, New York, and the American South, Simpson pursued her practice by training herself to see images in everyday events and social rituals, absorbing their import, as well as shaping her observations into photographic meaning, sharply delineating the spatio-temporal connection of her subjects to place.

FIRST LESSONS

The images are not timeless, universal signs. They are scorched with emblems and textures of their time and place (both in the garb and coiffure of the subjects). A photograph of two women wearing *hijabs* and semitransparent veils in the medina of Marrakech is instructive, not least because it is an agitated image. In the image it is clear that the woman at the bottom edge of the left corner may have just become aware of the presence of the photographer. Does the photographer have permission? This oft-repeated question inscribes the social contract between photographer and subject, especially when the cultural context demands it. It seems that this photograph demands an answer congruent with the question. The look in the eyes of the veiled woman, along with the sternness of her furrowed brow, does not signal any invitation. They merely place, for the record, evidence of her disapproval. Yet one cannot know for sure. There is

an ambiguity in the exchange of looks between photographer and subject. The struggle for power and control over the scene of representation makes the simple plot of this photograph an ambivalent one.

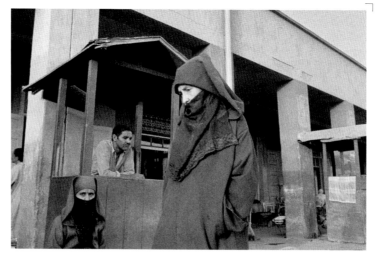

The encounter with the Moroccan woman is familiar, that is, if we apply an orientalist reading upon this scene of differences, with the barely adult Simpson occupying the position of the penetrating Western gaze, that look that pierces and enervates the subject. But here it is the photographer's subjectivity that is at stake. She is being judged, along with the instrument that seemingly authorizes her entrance into the orientalist context. Her subjects do not give ground—the larger looming figure at the central portion of the image has turned from the camera. She either is ignoring the photographer or is oblivious to her presence. She is buried in her thoughts, her tense, invisible body burrowed within the flowing outfit that all but conceals it. But this obliviousness is betrayed by the palpable tension that runs from her hunched shoulders down to the hands hidden inside her outfit, which does indicate a response to the camera's presence. Neither woman collaborates in the slow striptease of the photographic game that frequently strips the "other" naked, turning her into merely an object of desire. This kind of refusal has engendered a multiplicity of critical literature, especially with the advent of the publication of Edward Said's landmark book *Orientalism*[3] in 1978. The two women and the photographer are protagonists in a critical cultural conversation. Here we must see the exchange purely from the point of view of the subjects, whose gaze and body language dominate and seize control of the picture. Simpson must yield ground. She has lost the capacity to maintain the authority of the camera and its ability to invade the space of the other as most street photography tends to do.

In all the images from this trip, the confrontation between the Muslim women and the American girl inscribes a dialectic of power, about who has control over the image.

LORNA SIMPSON
Morocco (Moroccan Women), 1980
Courtesy the artist

104

Such struggle for power, for control over representation, has played a formidable role in Simpson's conception of photography and its capacity to enter a judgment of the scene of representation. The critical attitude that accompanies the photographic encounter is further distilled, years later, in Simpson's engagement with American racialized modes of representation and the bodies of black women. Yet, in contradistinction to the uneasy encounter with the Muslim Moroccan women, Simpson's other documentary pictures produced around the same period lack similar dramatic face-off. In other words, they are not dialectical. These pictures, shot entirely in familiar Western contexts, are not as contested. In Sicily, for example, the images, while clearly competent, are not as arresting. They appear hackneyed, depending as they do on clichés of tourist photography. We have seen such images before in countless establishments—pizza parlors, travel agencies, "Visit Italy" brochures— retailing cheesy Italian exotica. There is the image of robust, dark-haired Italian women full of merriment and so obviously delighted by the presence of the camera. The scene is as it should be: a combination of rustic charm and the simple joy of being alive. Another image is a street scene of a group of dark-suited men gathered in conversation in the middle of the picture. In the central foreground a young boy is playing, his smiling face crinkled in delight at an invisible object to which he has turned his head. In the background, to

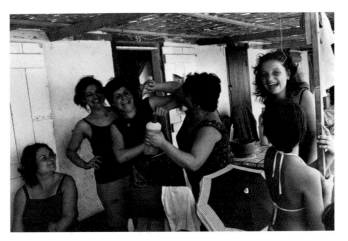

the right, a matronly woman dressed in black is leading a small child outfitted in ruffled white chiffon into a courtyard, while to the left, in the far background, stand another woman in black and a young girl in white. But the winning charm of the picture is also the true subject of the photograph: he is standing there, like the lover he models himself as, arms akimbo, an unlit cigarette dangling from the corner of his lips. He is a perfect caricature of the local gigolo. These images clearly betray Simpson's absorption of classic post-war street photography modes of observation.

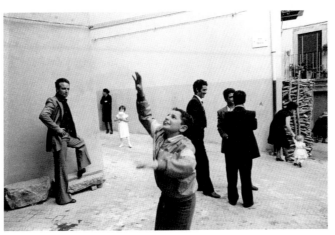

However, in subsequent images taken in New York there is clearly a sense that Simpson's perception of her own cultural context is far more acute and less dependent on the crutch of touristic exoticism. These images are shot across different settings but are mostly set within the urban milieu. The subjects are middle class, urban black Americans or immigrants in various ceremonial or ritual contexts, such as families attending a wedding, going to church, or watching a parade on Eastern Parkway in Brooklyn. The ease with which Simpson photographed these events is

LORNA SIMPSON
Sicily, 1980
Courtesy the artist

LORNA SIMPSON
Sicily (Street Scene), 1979
Courtesy the artist

reciprocated with a similar ease in the manner the subjects present themselves to the camera. One image in particular shows Simpson's debt at this time to the work of the great African American photographer Roy DeCarava, especially his classic book *Sweet Flypaper of Life* (1955), a collaboration with Langston Hughes.[4] The photograph in question depicts a young black woman in a tiered lace bridesmaid dress clutching a small, white-ribboned bouquet of flowers as she faces the camera. In the image there are four figures posed against the backdrop of a station wagon. The bridesmaid is standing to the left side as she leans slightly forward while supporting the weight of her

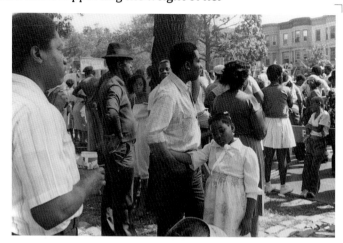

body with her left hand placed against the car's front door. In the middle is an older woman (also dressed formally in a white lace dress) half sitting inside the car's open back door. She is staring at the camera with a look of bemusement. To her immediate left stands another young woman holding a small child in her arms. The photograph is reminiscent of DeCarava's picture *Graduation, New York* of an extravagantly attired black girl on her way to graduation. Simpson's photograph evokes a similar sense of tenderness. This portrait of a black family displays the sensitivity that is the hallmark of DeCarava's analysis of black life in America, and may perhaps explain the ease one detects in these images. In a way, Simpson was working within her own culture. Notice that she has completely avoided the cliché of urban strife, poverty, and dilapidated neighborhoods in which black subjects are normally portrayed. These then are questioning photographs, images that go to the heart of black subjectivity and sense of the self. But are these images adequate to the task demanded by the encounter with the Muslim Moroccan women? We will soon discover the answer to this fundamental question in the decision Simpson makes in the 1980s.

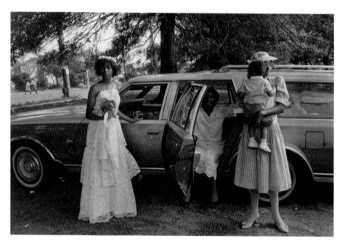

DEFAMILIARIZATION

Like most beginners in photography, Simpson, who was in her late teens during the period the photographs were taken, worked in the honored documentary tradition. The documentary tradition to which she had initially responded includes both the work of European and American modernists: men and women such as Henri Cartier-Bresson, Walker Evans, Dorothea Lange, Margaret Bourke-White, Consuelo Kanaga, Gordon Parks, Roy DeCarava, Robert Frank, and many others. Such photography, splashy with bravado and social gravitas or cool and distanced as was the case with Evans, had reached its height with the advent of the witnessing industry procured by photojour-

nalism and perfected in arty style through the invention of the "decisive moment" in the work of the likes of Cartier-Bresson and Robert Capa. This style became indisputably cemented in the public imagination in the post-war years.

Most practitioners who employed the documentary form had great belief in the mediated truth of the image, especially one that was generally concerned with the human condition; with the poetic beauty of the ordinary and the metaphysical power inherent in observed nature. The introduction of the less bulky handheld camera in the 1930s changed the nature of the photographic enterprise. Freed of the encumbrance of the stationary large-format machines of the previous era, photographers became more agile, an advantage afforded by the mobility the portable camera offered. It also changed the nature of documentary photography. As the twentieth century was being rapidly transformed, the documentary photographer was there to record and document it, to preserve, translate, and transmit its ideals of change and progress. This portable camera, in the overwhelming way it was used and in its attempts to penetrate social conditions, was both a sensitive and an indiscriminate machine. This machine in turn manifested a superficial image-mongering in the gossipy snapshot of the paparazzi. On the other hand, in the ponderous style of "concerned photography,"[5] it became a sort of ethical shorthand directed toward the most troubling parts of society. We shall not speak of the nature of this "concern," whether it lacked decorum or was just simply excessive.

Suffice it to say that from its very inception "concerned photography" was troubled and presumptuous. It was ready to be subjected to a radical process of defamiliarization: at once sensational (Arbus), detached, and severely objective (conceptual art). During this period in the 1950s and 1960s, American society was undergoing a profound and radical change. The changes brought about by the Civil Rights movement, the Vietnam War, and the Women's Rights movement touched the practice of photography in immeasurable ways, especially as artists became more inclined to deploy its methodologies and images.

Andy Warhol, that cool purveyor of the profound and the mundane, was one of the early contemporary artists to recognize the crucial shift in the practice of photography and the relationship between public images and the defamiliarization from their referent. In *Red Race Riot*, a large silkscreen of repeated images of a news photograph showing the police setting attack dogs on civil rights demonstrators in Birmingham, Alabama, Warhol was able to critique the fundamental flaw inherent in documentary photography, which though attentive to the event was less able in negotiating the signifier/signified relationship reading of the image solicited. *Red Race Riot* indicated a different photographic paradigm, one that turned from the photojournalistic tendency of the documentary as news to the more iconic treatment of photographic images as archives of public memory (from celebrity to the infamous, disasters, and the bizarre).

This shift, which was already clear in the photomontages of the 1920s and in the defamiliarizations of Surrealism and Dada, would occur frequently throughout the 1960s in the work of Richard Hamilton, Gerhard Richter, Sigmar Polke, and other pop artists. With conceptual artists such as Bruce Nauman, Ed Ruscha, Eleanor Antin, Adrian Piper, Dan Graham, Gordon Matta-Clark, Robert Smithson, Hans Haacke, and Martha Rosler, photography became a tool of documentation to be dissociated from the "concern" of the documentary practitioner. Photography was an instrument of investigation, a mechanism of critical analysis; its product a series of citations involving systems, experiments, preconceived narratives, "based in daily, lived rhythms or 'real time'"[6] that were no less true than the so-called unmediated images drawn by "pure" documentary. Photography at this juncture in contemporary art was fundamentally subjective. Simpson entered art school at the climax of the dialectic between the two traditions: one putatively objective and the other brazenly subjective. Needless to say, the latter view had the greater appeal and held more meaning for Simpson. The realization that there was a different photographic possibility would prove pivotal to Simpson's attempt to constitute a new discursive strategy for subsequent work. It was the strip of photographic territory she had to traverse in order to understand that photography was "fundamentally subjective," but also, that it was vitally philosophical.

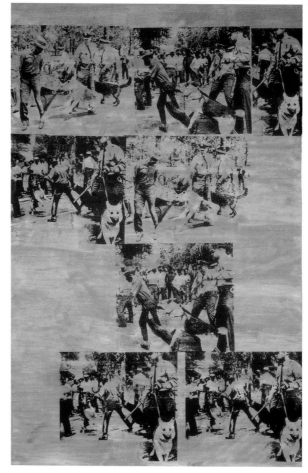

APOSTASY

For a young artist still discovering the world of contemporary art, such realization as was manifested through the encounter with multiple photographic tropes was not necessarily reassuring. By the time she enrolled in art school in New York in 1978, Simpson, like the rest who passed through the birth canal of the documentary school, had become an apostate. However, the transformation of her work would come only later, while in graduate school in San Diego. In 1982, after leaving New York for the West Coast, she would become involved in an artistic environment where procedures of working were radically different from those of her beginnings in New York.[7]
The art department of the University of California, San Diego, comprised a number of experimental artists including Allan Kaprow and Eleanor Antin. Owing to the performance- and process-oriented work championed by the faculty, regular attendance at performances was de rigueur.

The activities surrounding contemporary artistic procedures furthered Simpson's ongoing interrogation of photography. She was increasingly engaged with the analysis of the intermedia and temporal relationship between the performative act and the camera. She was in doubt about the adequacy of the documentary method as a way of

THE AMERICAN SUBLIME AND THE RACIAL SELF

We will see how and why this fresh logic of the photographic instrument held great appeal for Simpson, as was already demonstrated in *Gestures/Reenactments* and subsequently in *Screen 1, Screen 2, Screen 3, Screen 4* (all 1986) and *Completing the Analogy* (1987). The turning point in her work lies specifically in the fact that for her generation photographic inquiry became concerned principally with cogito, and it was not necessarily the drive to self-knowledge nor autobiography that compelled this shift. There were larger issues at stake: a whole social body and its pathologies. Let us give this a name: It is the spectacle of the racial self and the gendered body. Take the example of *Completing the Analogy*, in which a tousle-haired black female garbed in a crinkled cotton gown, her back turned to the viewer, appears to be facing a blackboard in an image in which foreground and background have been erased. The slightly animated pose contrasts dramatically with the text printed on the photograph, which reads:

HAT IS TO HEAD
AS DARKNESS IS TO.......SKIN

SCISSORS ARE TO CLOTH
AS RAZOR IS TO.............SKIN

BOW IS TO ARROW
AS SHOTGUN IS TO........SKIN

But insofar as this is concerned with certain practices of dissection, we can more properly locate its aesthetic properties as the ken of the American sublime: race and gender in social discourse. Therefore, to confront Simpson's early photographic work (1985−95) and the elliptical linguistic registers that ring it like a halo, we have to engage how the disquietingly straightforward, pared-down images open the viewer up to a vast epistemic field. It is a field rooted in a particular type of violence. This violence is grounded in methods of subjection and denial. Access to its disclosure therefore requires more than the tacit acknowledgment of its historical base and its temporality.

Over the last century, manifold cultural examinations and artistic investigations have been opening knowledge of this violence to viewers. D.W. Griffith's *Birth of a Nation* (1915) is a key example of the iconographic violence rooted in the American sublime. Popular media, literature, and countless Hollywood films are saturated with such images. It is never said enough that nothing escapes the racial sublime and the epistemic violence that surrounds it in the American civilization. The scrutiny of the racial sublime constitutes a key philosophical and methodological framework of Simpson's critical project. But what is this violence and how does it frame her artistic

procedures? Or, rather, how has Simpson deployed the dispersed regimes of this violence to explore the limits of the body, the black body mounted on the scaffold and bound up in its suffocating hold? Then there is the female body. And then the black female body. And then . . . Simpson stages her work in the tumultuous events of the racial and gendered self. Perhaps we can see why it is possible to speak here of the double displacement that is evident in all her work, especially in the constant insertion of the photographic subject into the zones of racial and female identification. The first displacement connects to the question of what it is to be black and female. This frame represents the universal and the particular in her line of enquiry. The second displacement is on the narrower subject of what it means to be African American and American simultaneously. This frame is driven by the concepts of diaspora and sub-alternity; nationality and citizenship. The relay of positions and modes of address also touch on specific formal and methodological issues: the inter-media relationship between photography and film, text and image, speech and narrative. All of these form the backdrop of what this essay seeks to explore.

RUPTURE, OR THE MADNESS OF RACE

There is in the "mythology of madness" the oft-repeated story of the radical therapy effected by Phillipe Pinel when he released the madmen and madwomen from their chains in Bicêtre and Salpêtrière hospitals in Paris in 1794. Pinel's freeing of the madmen and madwomen was said to have ushered in a revolution in the treatment of madness. Not only did he free these men and women from their literal chains, he simultaneously, through their deincarceration, also freed them from the stigma to which the chain had interminably condemned them beyond repair.

By the same token, Pinel did not so much free the insane from their hellish confinement as much as he released their madness from total censure. In this way he returned them back into the world, or rather, into the social government of the asylum from which the insane had been banished. And in which for centuries scores languished, under lock and key, behind high walls, where no "serene" gaze of rationality and respectability would ever fall on that insolence that represents the ruined human character.

In America, race constitutes its own form of madness, along with its own asylums and governmentalities. From the earliest moment that European colonists arrived on the American shores, race has been the great alloy of a potent social experiment, one that produced slavery and the plantation economy. If the Bicêtre and Salpêtrière hospitals were more than therapeutic zones—being as they were places of seizure—the confinement on the plantation under slavery mobilizes similar senses of capture and stigma. Race in America simultaneously represents the unspeakable and the irrepressible, as well as an epistemological model of biological differentiation that produces a prodigious body of discourse and representation. And like madness in the asylum, it enjoys a particular kind of censure behind the high walls of its own asylum. Except, unlike the asylum, which is ringed by thick, mortared walls and protected by a forbidding gate, the madness of race exists nakedly visible in the tumescent flesh of the American social ideal and is practiced in the open terrain of the cultural landscape.

Toni Morrison has productively explored how the episteme of race as a literary device of social and political differences was constituted. She makes us aware of how the discourse of race suffuses the canons of early and modern American writing, particularly the novels of America's most celebrated writers. She argues that the madness of race, along with its utter naked visibility, is part of the unique character of American literary arts. According to her analysis, a cursory search into American literature reveals the obsessive nature of the racial attitude in what she identifies as the uses of an Africanist presence to elevate the representations of literary whiteness and at the same time ameliorate the lurking sense of a human bond that connects the enslaved and the free. This presence, as it were, stages a discourse, a funnel through which the dialectic between enslavement and freedom could be passed. Morrison came to this insight through close readings of Edgar Allan Poe, Herman Melville, Nathaniel Hawthorne, Harriet Beecher Stowe, William Styron, William Faulkner, Ernest Hemingway, and many others.

My curiosity about the origins and literary uses of this carefully observed, and carefully invented, Africanist presence has become an informal study of what I call American Africanism. It is an investigation into the ways in which nonwhite, Africanlike (or Africanist) presence or persona was constructed in the United States, and the imaginative uses this fabricated presence served. I am using the term "Africanism" not to suggest the larger body of knowledge on Africa that the philosopher Valentin Mudimbe means by the term "Africanism," nor to suggest the varieties and complexities of African people and their descendants who have inhabited this country. Rather I use it as a term for the denotative and connotative blackness that African peoples have come to signify, as well as the entire range of views, assumptions, readings, and misreadings that accompany Eurocentric learning about these people. As a trope, little restraint has been attached to its uses. As a disabling virus within literary discourse, Africanism has become, in the Eurocentric tradition that American education favors, both a way of talking about and a way of policing matters of class, sexual license, and repression, formations and exercises of power, and meditations on ethics and accountability. Through the simple expedient of demonizing and reifying the range of color on a palette, American Africanism makes it possible to say and not say, to inscribe and erase, to escape and engage, to act out and act on, to historicize and render timeless. It provides a way of contemplating chaos and civilization, desire and fear, and a mechanism for testing the problems and blessings of freedom.[10]

Abolition literature and the slave narrative were direct literary responses to the disjuncture of racial difference. This disjuncture has been well preserved in the American aesthetic imagination, from the vaudeville black face of Al Jolson to President George W. H. Bush's deployment of Willie Horton in an advertisement during his presidential campaign in 1988. During the Black Arts Movement of the 1960s the disjuncture of race as an artistic paradigm made a return in the form of black nationalism, while in the 1980s it was penetrated by the insight of cultural and postcolonial studies and postmodernism. In contemporary art, a denotative and connotative Africanist presence has been abundantly used by artists—black and white alike—who find in the form of this spectral subject a language for the racial sublime. Simpson, Kara Walker,

Glenn Ligon, and Fred Wilson are some of the better-known younger African American artists who have wrung meaning out of the vast Africanist visual archive and who have also departed from the props of black nationalism of the 1960s. They have devised a more nuanced if not always successful philosophical engagement with its imagery. If the madness of race suffused the work of these artists—providing, as their work proved, a topic of serious theoretical and historical reflection—it has not come without misgivings on the part of the critical establishment. As Morrison correctly observed, "When matters of race are located and called attention to in American literature [and art], critical response has tended to be on the order of a humanistic nostrum—or a dismissal mandated by the label 'political.' Excising the political from the life of the mind is a sacrifice that has proven costly."[11]

However, the work of these artists was accompanied by a number of broader theoretical positions. One such position could be found in the work of the Martinican psychiatrist Frantz Fanon, whose book *Black Skin, White Masks* sought to unravel the power of the racial asylum over its inhabitants and administrators.

I want to think through some of the implications of race and madness in connection with the important work Fanon did in the asylum in Blida, Algeria, during the colonial war there in the 1950s. Early in his career Fanon had grasped the link between racism and madness. Similar metaphors used to describe Pinel's historic deincarceration of the insane have been applied to Fanon's work in Blida. In Algeria, Fanon wanted to demonstrate through the case study of asylum inmates interned in colonial jails that racism literally drives the subject insane. In order to offer the inmates effective therapy, he, like Pinel, had to release them from the chain of inferiority imposed by colonial racism.[12]

Fanon's work then was a double therapy, dealing with literal madness and colonial racism. Lorna Simpson's interrogation of race in her work has consistently attempted to unravel the underlying madness of the same: the racial sublime, a combination of desire and repression. The racial sublime operates on the prodigious multiplication of social signifiers along with the phantom forms of subjection in everyday life in America. No wonder Cindy Sherman suppressed an early work in which she developed a number of female characters in black face, adding to the archive. In this series of untitled, photographic impersonations produced in 1976 she projected the romance of race back into the scrim of the racial sublime.

But in Simpson's work we will notice that the selfsame racial sublime was not only a romance but was accompanied by the episteme of violence to the black body, which is doubly violent to the black woman's body and psyche. Therein lies the undercurrent that lurks in many of Simpson's images. While the theoretical basis of the intersection of race and gender in Simpson's work is soundly grounded in the broader project of feminism, as her project doubtless is, it still does not obscure the basic premise argued by many African American feminists such as Michelle Wallace[13] and bell hooks,[14] that mainstream feminism has been quite blind to the violence of the racial sublime. Within this terrain Simpson's work has introduced a fundamental dialectic, namely, the relationship between plenitude and negation. The privileging of the black female subject in her photographic projects addresses the question of plenitude,

while the insistent refusal of the face of the woman alludes to her negation by the culture at large. In fact, much of Simpson's work proceeds from the establishment of this crucial disjuncture.

THE NEGATION OF PORTRAITURE

In all of Simpson's attempts at interrogating forms of hysteria that surround the racial sublime, what the viewer is confronted with time and again is the paradoxical denial of the façade of the stereotypical victim (woman and black, black and woman). That is to say, the superficial characterization via portraiture of the face on which could be read the inscription of racial, gendered, and sexual violence. By denying this access, Simpson reworks the ethical paradigm of the documentary, critically questioning the maudlin sentimentality introduced in early photography of the face as a window into the soul of a subject. The face has been a cheap trick in photography, wherein shallow psychological and morality tales become conventions for reading deep character into nothing but a mask. Proponents of this trick want us to believe in the oracular certainty of the mask, as if a more penetrating insight can be gleaned from the gaze of the subject. By having her models face away from the camera, cropping off the head and screening the faces, Simpson was constantly performing surgeries and excisions, cutting away the skin of resemblance. In so doing, she was able to abolish the façade and the distraction of the gaze. To address this conundrum she has invented her own countersystem of knowledge that plays on the linguistic nature of everyday speech: tongue twisters, pantomimes, riddles, and puns. The locution is richly American. It is self-knowing and self-effacing speech, an exchange of tongues to fit into areas the gaze may not reach.

For example, in *Twenty Questions (A Sampler)* (pp. 12–13) Simpson uses the nineteenth-century circular device of portraiture to negate the portrait of the subject and thereby deny and eradicate the insolence of the gaze. The subject's face and gaze do not encounter the viewer's. Yet Simpson goes ahead to lead us into the trap, inviting us to make judgments of her character, to cast aspersions, to damn with an epithet, indicate delight, or register horror in the clear rendering of five questions, each related to the will to define who this subject is. The questions run thus: "Is she as pretty as a picture" "Or clear as crystal" "Or pure as a lily" "Or black as coal" "Or sharp as a razor." It is an effective ruse: four identical images of a reversed portrait bust featuring a woman's back, her features obscured and masked by a shock of lush pomaded hair (hair plays a crucial role in the work) that runs down to and conceals her neck, revealing only the naked vulnerable flesh around the shoulder, down to the upper reaches of the back, which is covered by a simple calico chemise.

It is a clinical image, undifferentiated like a police line-up photograph, elements of which she has appropriated from Alphonse Bertillon's infamous machine. As we know, the line-up is an agent of identification and misidentification. Simpson has used and tweaked it, so that the self-repeating image calls on the viewer to decipher the characterological zone into which to confine the subject. Didi-Huberman calls this the "legend of identity and its protocol."[15] The constant use of the line-up by Simpson feeds this legend, yet it assumes an entirely different protocol by the sheer obduracy of

the subject's refusal to declare an identity, to reveal herself before the iron law of the legend's damning gaze. This is the function of the negated portrait, to open us up to the original sin fundamental to the miasma of racial hysteria.

THE HYPOCRITICAL GAZE

The gaze is unforgiving. It operates below the surface and under the skin, even more so with all the scopic devices that clatter around all contemporary existence. From airport scanning machines, MRI scanners, Doppler tests, to conventional cameras, these instruments magnify the gaze, leading it into the deepest recesses of the body. *Looking Devices* (1996), a grid of photographs documenting various examples of binoculars, is a commentary by Simpson on the prosthetic attachments of the gaze. In this instance, the key issue for her was the subject of voyeurism. However, today the machines of voyeurism have proliferated. These numbing instruments that suffuse life and in a flash of shattering immobility fix the subject or body into a classification system, into a zone of knowledge, tabulated in a ledger of all-encompassing visibility, have become what must be overcome for us to have bodies. Didi-Huberman might have declared such a system hypocritical, by which one may point to the hypocrisy of the photographic apparatus. Here "it is hypocrisy as method, a ruse of theatrical reason as it presumes to invent truth."[16]

Perhaps the claim that the camera is an instrument of cogito bears examining. To get around the apparent contradiction of such a statement in response to the hypocrisy of the apparatus, it should be added that the camera is equally a blunt instrument. It is the latter understanding, one suspects, that led to Simpson's rethinking of the documentary method by seeking to detach the camera from the body. Which asks the questions: By what method then does the camera know the truth of the body? In what way is it an instrument of cogito? In part, Simpson's work has been about resolving this contradiction. By nominating the photographic apparatus as both agent and double agent. By forcing the camera to betray its clandestine undermining of the body, while making it serve the task of inventing an entirely different subjective protocol by theatricalizing the body through the selfsame camera. *Wigs* (pp. 40–42), a large-scale series of fifty individual photographs of wigs printed on felt, exemplifies the theatricalized body, albeit its surrogate form, disciplined within the grid of scientific rationality. But *Wigs*, despite its impressiveness, is in many ways a transitional work, developed at a point at which Simpson was beginning to erase the trace of the body entirely from her work; suppressing even the corporeal parts on which the marks of gender and race had been bound. Here the absent portrait is being dispersed, broken down into surrogate parts.

WEIRD SYNESTHESIA: THE SPEAKING ORGAN AND PROPHESY

But let us hold on a while longer to the negative dialectic of the portrait—understood from the perspective of the hypocritical instrument—and enumerate other ways it furnished Simpson with her ordnance of philosophical arguments. We know that the details of this argument were established in the post-documentary images. But the earliest account of it in the refusal of the Muslim Moroccan women was purely

serendipitous. Since then, for Simpson, portraiture has served the function of refusal and dissidency, like the Muslim Moroccan women a decade earlier who, though they did not turn away, yet denied Simpson full access to their portraits. Whatever the lessons learned from that earlier encounter, it was properly absorbed, perhaps unconsciously, into the latter work. The subject is never fully visible. There is never eye contact. Nor invitation to intimacy. Nor familiarity. It is not a question of the decorum of portrayal or resemblance: The target is the limits of photographic depiction and representation, vision and visibility. The more to underline the hypocrisy of the camera as it presumes to invent truth. The linguistic association is nothing more than the opportunity for Simpson to rubbish the presumption. But it is much more than that, for that would be too easy. In fact, the linguistic connotations unmask the violence

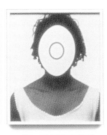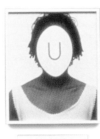

AMNESIA ERROR INDIFFERENCE OMISSION UNCIVIL

LORNA SIMPSON
Easy for Who to Say, 1989
5 color Polaroid prints, plastic plaques
31 x 115 inches overall
Collection Mr. and Mrs. Howard Ganek

inherent in racial hysteria. As such, *Twenty Questions (A Sampler)* manifests an attempt to render the symptom of the hysteria, which is not at all dependent on mere representation but rather is linked to mental images burned into the cerebral cortex.

In 1989, Simpson produced a series of photographs in which she introduced images that may be seen as complete portraits in that the faces are neither turned away nor cropped out of the frame. These images were not a complete concession to portraiture or resemblance; rather, they are informed by the underlying assumption of the insufficiency of visuality alone to explain phenomena. In this case, which is partly experimental, Simpson appears to want to invest the gaze with a new kind of capacity: the capacity of speech. In the portraits that ensued from this experiment, text has been overlaid on the faces, partially obscuring the full identity of the subjects. In *Sounds Like* (1988), *Proof Reading* (p. 27), and *Easy for Who to Say*, the obliterated eyes or faces are covered by either a single word related to subjectivity or letters related to sentence structures, becoming the speaking gaze. Here the eye/gaze may not be allied with vision, but it certainly is with prophesy. It is literally a speaking organ in a form of weird synesthesia.

In *Easy for Who to Say*, five identically formatted Polaroid photographs are presented in a repeating horizontal line. But we do not see the faces that bear the portraits, since they are not vehicles of recognition. It is already quite clear that these enigmatic images are not portrayals but ciphers. For where the eyes/gaze would have been, Simpson has superimposed five vowels, each representing a word: for example, A = Amnesia; E = Error; I = Indifference; O = Omission; U = Uncivil. In *Sounds Like*, the Polaroid portrait shows a model wearing a white blindfold across her eyes with the lettering I-WIT-NESS etched across where the gaze would have been. The work performs the task of bearing witness and inscribes subjectivity simultaneously. Like *Easy for Who to Say*, each letter and the associated word take on the charge of delineating a mnemonic game; a disturbance perhaps in the experience of the subject. *Proof Reading* similarly engenders associations with

ophthalmologic examination. All three works are principally concerned with methods of disclosure whereby the structure of memory is conjoined with the capacity to see, to visualize, and to be visible: to be believed, issues already anticipated in *Waterbearer* (p. 15).

The degree to which Simpson refuses full disclosure of her photographic subjects' faces is part of her attempt to limit the connotation of autobiography. It is also a denial of the anxious, stereotypical victim, that is to say, the superficial rendering, via portraiture, of the face of the black woman as victim on which could easily be deciphered the inscription of racial violence or sassiness. This matter is adjudicated in *Untitled (2 Necklines)* (pp. 24–25) and *Stereo Styles* (pp. 22–23). What is in a face if not, as some would argue, the oracular insight gleaned from the gaze of the subject. But with the eyes bound by the glaucoma of non-sight, words become the manner of prophesy. The counter-measure against the hypocrisy of sight.

I suggested earlier that negation is pivotal to Simpson's use of the portrait. To understand the way the liminal figures who inhabit her photographic tables function in relation to representation, we would do well to linger on the nature and status of the photographic portrait: between the portrayed and depicted, the represented and the documented, the visible and invisible, the inchoate and the overdetermined. From very early on, the figures appear to have been assigned a rather standard set of outfits befitting their roles as stand-ins for a generic racial and gendered self. The plain smocks, the unadorned studio settings scrubbed of every detail, almost as if the studio were an isolation chamber in an institution. Because the figures are almost always black women, they represent a kind of every black woman. They have no names. No faces. No identity except their biology. But they are made alive to us via their symptoms. Didi-Huberman's keen insight into the work of Charcot and his treatment of hysterics at the Salpêtrière Hospital in Paris is apt in exploring what Simpson is concerned with:

> [The symptom of race]...in its ever-renewed reification of bodies, in the maintenance and mastery, and even jouissance,...In this way it fomented a perverse relation...constantly asking [itself], in a certain way the ultimate perverse question: "Of what corporeal substance is a woman made?"...Confronted with this quest, the hysterical body consented to an indefinite reiteration of symptoms, shreds of responses, a maddening reiteration. For a perverse authority, it was titillating. Iconographable.[17]

But is the body of a woman, much less that of a black woman, so easily procured by the machine of iconographic reification? Sherman approaches this question in one way in her send-up of the conventional female stereotypes merchandised in Hollywood cinema, or turns them into tools of historical struggle in the Renaissance portrait styles she pilfered to serve her ends. Simpson approaches it differently. Because she eschews pure portrayal, she arrives at portraiture by way of negation, canceling out the visage; suppressing and obscuring the identity of the sitter. In this way her images resemble no one. The portraits are resemblances of a general kind that are bound up in

the limits of race and gender. In these quintessentially anti-portraits, one is raced and sexed: black and woman.

INDIFFERENCE: ON NOT BEING PROPER SUBJECTS

Because Simpson rarely divulges the full identity of her sitters, the portraits she composes stand not just for a general figuration, they stand for an abiding American Africanism. The models in the photographs are never proper subjects. They are shadow figures, specters, archetypes of the American racial sublime. Here the model is thoroughly dissociated, and turned into a figure of indifference. Gilles Deleuze's opening sentence in *Difference and Repetition* speaks directly to Simpson's method, insofar as the indifference to portraiture is concerned. He writes:

> *Indifference has two aspects: the undifferentiated abyss, the black nothingness, the indeterminate animal in which everything is dissolved—but also the white nothingness, the once more calm surface upon which float unconnected determinations, like scattered members: a head without a neck, an arm without a shoulder, eyes without brows.*[18]

It is quite clear that throughout the construction of the works the artist has been carefully gesturing toward that plenitude that marks the position of the black figure in the American imagination. The black figure is abundant with meaning and has filled to the brim the corpulent estate of the country's artistic legacy. The black figure is a monstrous body: at once threatening and benign, capable of the most horrific actions yet essentially a child. In the carefully chosen texts that accompany the photographs, it is quite clear that the figures we see are struggling to exceed their limits. It is also clear that these are troubled bodies, excessive bodies, subjugated and unmanumitted bodies.

Here we return to the principle of negation, for the Africanist presence is essentially a vehicle of negation and negativity. There is never a surplus that accrues to that figure. It is a disfigured subject, marked by indifference, that suffers the malediction that racism produces; confined in "the undifferentiated abyss, the black nothingness, the indeterminate animal in which everything is dissolved." It is in this sense that Simpson's approach to portraiture opens up the unresolved role of the black figure in a generally racialized society that is steeped and invested in the production of indifference.

VOICE AND MIME

Much of Simpson's work imbricates language, speech, and text. Language is employed like a lever to pry open the lid of the unconscious. Here text plays a subsidiary role. However, when it approximates speech, it functions like a memory trigger in relation to a visual cue. The text panels also confront the viewer with a fundamental contradiction between the sense of vision and voice as separate forms of knowing: between seeing and speaking. If we are to reconcile this contradiction, then much of Simpson's work is not simply annexed to text/image relationship, it is fundamentally audiovisual.

REPETITION AND DIFFERENTIATION

In *Five Day Forecast* (pp. 16–17), for example, Simpson deploys a staccato device, a kind of mechanistic action of repetition and differentiation. One feels as if doused with a shower of recriminations. Arranged like a weekday diary—from Monday to Friday—five nearly identical photographs of female figures with arms folded tightly across the body, just below the breast, form a single horizontal line facing the viewer. Above each image, the day of the week is correlated with two words running beneath each image, forming a total of ten such words. A word is repeated and immediately differentiated to signal the shift to a different register of meaning. For instance, we shift from misdescription to misinformation to misidentify, misgauge, and misconstrue. In each case, *mis* is repeated and comes to stand almost like an object. Each repetition functions like a mark of emphasis, ballast for the point of differentiation that announces yet another set of clues. Here, as with the case of portraiture, an object of negation is introduced to indicate the status of the subject's relationship to the narrative. It is a sonic recall attached to a linguistic sign. Language not only involves the voice, it is lashed to the ear. Here the aural landscape and sonic texture of the voice combine to propose the non-concordance of the figure which constantly slips out of recognition, which falls back into the void, down the abyss.

Memory Knots (1989) and *Guarded Conditions* (p. 135) are similarly structured, each adopting the same principle: The former is organized by the logic of a journal (a similar arrangement is deployed in *1978–1988*, pp. 28–29) and the latter like a flow chart of symptoms. Both distill and elucidate in clear terms the chief historical argument—race and gender, memory and amnesia—that runs through much of Simpson's work. *Guarded Conditions* is monumental, slightly larger than human scale. Simpson uses the iconography of the police line-up to high effect in the pose of the model, a big-boned black woman clothed in the signature unadorned white, hospital-issue wrinkled gown, standing with both arms folded behind her back. There are six images in all, comprising a total of eighteen individual prints. Though the arrangement of the images may indicate they are repeated, they are in fact not exactly the same picture all the time, as if mimicking chronometric photography. Above the images, a large sign like an advertising shingle is hung and beneath runs a band of fevered verbs—skin attacks, sex attacks—repeated like a mantra. But in this case it is more an urgent act of repetition and differentiation than pure denotation. The repetition and differentiation of sex and skin attacks—the inferno of the subject—serves to conjunct the horizon of race and gender discourse as an attack and stain on the subject.

GRAIN OF THE VOICE

Does the text sponsor the image or vice versa? Is the image part of an imaginary domain, one that has lapsed to the rear of recognition and must now be coaxed back with words? These questions bear on the proper understanding of the artist's enterprise. Simpson's facility with language is not merely technical. It is not part of the compositional technique of a writing course. It is located in discourse, and this is

what makes her lines bristle with such authority. The rigor and discipline of her lines are not unlike that pursued in the poet's ardor to stage in language the materiality of speech. The grating sound of words translating terrible deeds against identity; the grain of the voice communicating the infamy of the body. The cadence of the voice (and its voicing), the staccato and cool precision of delivery make impossible the eradication of a single line or word. What the reader/viewer experiences is the climax of a radical tension, the meaning of each line, the acerbic brevity of a compositional rigor that recuperates the dispersed subject, brings her back to historical visibility. Here words are laid on the grounds of each figure or on a separate plaque attached next to or affixed between frames or on the image, like slabs of stone on pavement. Like sentinels demanding recognition, each word sitting on the white sheet or etched on a black plastic rectangle becomes an object, a thing in itself, not merely a sign. This is clear in the arrangement between image and discourse in *Three Seated Figures* or violence in

her story

Prints Signs of Entry Marks

each time they looked for proof

LORNA SIMPSON
Three Seated Figures, 1989
3 dye diffusion (Polaroid) prints, 5 plastic plaques
30 x 97 inches overall
Collection Carol and Arthur Goldberg

Double Negative (p. 30). Each of the text panels sublimates the literal denotative conjunct. In *Double Negative*, a stacked vertical panel of four Polaroid photographs consisting of a single image of a braided hairpiece formed into a circle, there is an ungiving solidity to the appearance of each text panel between the images. The four repeated images suggest a noose, while the verticality of the stack gives the impression of the scaffold. Language and image are used to represent the violence of the Jim Crow mob, bringing to mind the image of the lynched body. Consequently, the relationship between text and image in the work is completely different from the way the caption is used to domesticate photography, which always turns the image into an illustration of something rather than a complement to an event.

INTERMEZZO: WORKS FROM THE MID-1990S
I have been interrogating the extent to which Simpson invested her practice with certain features of American Africanism, in the inferno that is the American racial sublime. Throughout this exercise, we saw how the racial sublime invented a veritable asylum out of the plantation. When we entered the asylum we saw that it was drenched with the deposits of black female trauma that since the early days of slavery attacked and infested the body, producing a toxic stench. Simpson shows how unbearable this stench had become in representation. But by 1994 she had grown weary of stalking this body. She had become exhausted with attempting to lance the boil of American racial agnosia. Though her contemporary Cindy Sherman would persist and go on, ad infinitum, plying the same impersonation tropes, for Simpson gender and race had become intolerable subjects. She was at the end of her tether.

In 1995, she meticulously began scrubbing her images of the iconography of racial and gendered bodies. She turned instead to what could be called the rumor of the body. She turned to innuendo and insinuation because the female body had slipped from the stage to attend to certain carnal rendezvous and assignations, to the pleasures of the body. Simpson's new work in the spring of 1995 suddenly introduced images in the documentary mode that were completely devoid of figures. Instead, there were photographs of real sites: landscape, cityscape, interior and exterior architecture. She was setting the stage, as it were, for what was to come in her films, in which identity of the female kind would be rendered quite visible and play a crucial role in her exploration of the multiplication of feminine roles and identities.

The works that make up her "Public Sex" images are not in any sense entirely new, being as they were extracts from a larger compendium of images Simpson had built up over the years, stretching back to her early beginnings. So while she had abjured images with any referential—documentary—facture, she did not entirely stop photographing scenes of everyday life or events. During trips to other countries or drives around or outside the city, she had continued all the while photographing architecture and landscapes and depositing the images in a growing archive of notebooks, each image carefully annotated with commentary. The "Public Sex" series grew out of these notebooks. They represent a partial return to her beginnings in documentary, except where a moat had existed between them, she now constructed a bridge to link them: between that past and the present in order to realize an entirely different view. Rather than explicit image/text disjunction, Simpson abstracted the associative content of each image, setting them up as scenes and vignettes of public encounter and enlivening them with short narratives. There is something self-consciously melodramatic about the works, as if she had placed her visual tongue firmly in cheek. She was employing the implements of the detective story by assuming, in some images, the persona of the private eye or a reporter. The combination of images with snippets of dialogue, some of which identify places, is a far cry from the antiseptic institutional spaces of the previous work. These pieces clearly prefigure Simpson's move into film.

The Clock Tower (pp. 50–51) shows a hulking view of a tower photographed from a distance and placed dead center in the image. The two clocks embedded on the south and east face of the tower are slightly misaligned (one face reads 8:21 and the other 8:24), recalling Felix Gonzalez-Torres's elegiac *Untitled (Perfect Lovers)* (1987–91), a sculpture of two out-of-sync generic white clocks. *The Clock Tower* follows the trajectory of a conversation overheard—note again the conjunction of audio and visual, the eavesdropper and the voyeur simultaneously—between two people, man and woman—who work in the same office. (The conversation in *The Clock Tower* presages the hilarious series of pas de deux that will emerge in Simpson's first film, *Call Waiting* [see pp. 60–61].) However, in the present conversation, the two lovers are discussing details of their after-work assignation in the tower where the clocks are. Close reading of the text, along with the cadence, inflections, pauses, and descriptive elements of the unfolding drama, reveals Simpson's keen ear for intrigue, her perspicacious observations of the mundaneness of people's lives and desires;

124

their constant pursuit of dangerous thrills and petty gratifications. From the breathy planning for an illicit meeting by two co-workers who obviously relish the edge of danger associated with doing it right there in the office; to the casual racism that the folks in *The Bed* (1995) have to endure as black people lodging in an upscale hotel; or the homoerotic encounter in *The Park* (pp. 54—55), where the cruising "sociologist" haunts men's public bathrooms in search of sexual fulfillment on the pretext of some unstated research assignment; or feverish sex in a parked car in the imagined silence of the vaulted space in *The Car* (1995), Simpson, like a detective, places us in the center of a psychosexual game and of dream narratives.

Each of the work's prominent scenes designates both an object and a place. The car, bed, rock, park, clock tower, each acquires an enigmatic fetish character. For example, the scene and narrative of *The Staircase* (pp. 68—69) seem completely drawn from an element in Freud's essay "Dream-Work," published in *The Interpretation of Dreams*. In the case of "A modified staircase dream," the patient's oedipal fantasy about his mother is played out in a scene in which he dreamt about repeatedly climbing the stairs while accompanied by his mother.[19] A comparable sexual anxiety and enigmatic tension is illuminated in the chilling silence and empty image of the curvilinear staircase, the form of which, along with the ambient chiaroscuro projecting deep into the nave on the left corner of the image, no doubt mimics the folds of a sexual organ. Nevertheless, the object/place relationship transmits the idea of zones into which inner desires, or places of intimate encounters, are displaced. Again one should note the degree to which Simpson has honed her skills of hearing and observation, skills so evidently natural for cinema.

The soft-focus, woolly, inky surfaces and the moody dramatic lighting that wash over the large expanses of the images convey a sense of film noir.[20] However, the noir genre does not, as some have argued, carry over to the films. Rather than cinema, the structure of films like *Call Waiting* and *Interior/Exterior, Full/Empty* (see pp. 62—64) is drawn from television. It is a classic send-up of daytime soap operas. Simpson's *31* (see pp. 88—89) enlarges this framework, only in this case, the tracking of the single female character over a period of thirty-one days is much in the mode of "reality television." Yet *31* draws from the structure of the diary, a method already employed in earlier photographic pieces such as *Five Day Forecast* and *Memory Knots*. Nothing is arbitrary in the planning and execution of Simpson's works. Each tableau or mise en scène is carefully planned and continuously edited and pared until the work strikes the right psychic balance and visual impact.

WHAT DOES A WOMAN WANT?

Freud's famous question remains a fascinating problem in terms of the psychic and corporeal drives that determine female desire. While Freud never found a satisfactory answer to his inquiry, it was more than compensated for in his theory of the castration complex and penis envy,[21] whereby the absent member, the missing part now inhabited by the lacuna of the feminine sex, indicates the struggle between man and woman; the wish and desire of the female to possess a penis. For Freud, perversions of female sexuality arise from the wish to have the male organ, an organ that, having

been castrated, has been folded back and now returns as the erogenous clitoris. Freud seems to suggest that the relationship between men and women is fueled by envy or jealousy. Does the woman wish to castrate every man in sight so as to diminish the wish to reattach the absent member? Joan Copjec makes an important point about the difference between jealousy and envy (a frequent trope in film noir that often leads to murder, which then becomes the raison d'etre of the film; this is not altogether different from how it is expressed in Simpson's films). Copjec quotes *Crabb's English Synonyms* as defining them thus: "Jealousy fears to lose what it has; envy is pained at seeing another have that which it wants for itself."[22]

WHAT DOES THE BLACK WOMAN WANT?
What this suggests is that in Simpson's work the question of gender that is constantly inscribed hinges on this dialectic between envy and jealousy; between absence and fulness, negation and plenitude; between the oedipal and the castration complexes. *She* (p. 37), a four-panel, horizontal work showing a sitting woman dressed in a brown suit and buttoned white shirt, implies through the hand gestures in each image that the space of lesbian sexuality has to be included in the dimension of gender that has preoccupied the artist. In the first panel from the left, the sitter lounges laconically with her hands gingerly placed forward on her thighs. The second image that follows is more aggressive; the sitter appears to grasp the crotch (in search of the missing penis?). The third panel is more diffident, as if upon finding the member gone, she now wants to cover up her embarrassment, while the fourth and final panel shows her falling back to resignation. If the loss of the penis points toward the development of perversions in the female, as Freud noted, *Suit* (1992), another piece drawn from the same sitting, completes that claim by Freud. But this is questioned by Simpson in the text panel that accompanies the full-length portrait of the woman standing with her right hand on her hip, back turned to the viewer. The text reads:

> *An average size*
> *woman in an average*
> *suit with illsuited*
> *thoughts*

This does specify that the woman's response to sexuality is not passive and can be accompanied by a level of aggressiveness. In *Call Waiting*, Simpson picks up this quarrel again in a series of vignettes showing various characters in a multitude of duplicitous roles, with lovers conversing on the phone, double-crossing and being double-crossed. *Call Waiting* is as much about the search for pleasure and the frustration of desire as it is the locality of the struggle for power between women and men. Simpson positions the woman at the center of this conversation, making her both the protagonist and antagonist in a form of oedipal display of angst between various couples. "What does a woman want?" intones Freud. Fanon recalibrates the question and turns it into "What does the black man want?"[23] It seems we are not yet done with this oedipal quarrel. Fanon is less charitable with the black woman who loves a

white man than with the black man who sleeps with a white woman. For him, when the black woman sleeps with the white man, it is a betrayal of the black man, but the black man who sleeps with the white woman is just getting revenge for his castration.[24] With Mayotte Capécia, the black Antillean woman who desires and loves a white man, the weight of an entire discriminatory and misogynist pedagogy, a whole weltanschauung, is brought to bear by Fanon on what he perceives to be her betrayal of the black man.[25] The contradiction is that Fanon ascribes a connotation of inferiority to the black woman's desire, even suggesting that the black woman is the authentic object of the black man's desire. This would mean then that the black man is an envious man, whose decapitation fuels his psychosexual frustrations.

Simpson cares not a jot about resolving the problem of the phallus and the way it has weighed negatively on female desire. Neither is she deeply concerned with the pacification of the black male ego. She is most concerned with the fulfillment and enjoyment that black women or women of color (notice that the female characters in *Call Waiting* are either African American or Asian) derive from their sexual empowerment. *Interior/Exterior, Full/Empty*, a seven-channel film shot in black and white, takes up the challenge of elucidating the place of female desire. Filmed in sequences of pairs of women or single female characters engaged in conversation with unseen characters on the phone, each segment of the work makes women—black women—the locus of conversation. The film mediates the absence of the black male from a distance. In the final portion of the sixth segment, two male characters—one black, one Hispanic—appear at the closing of the film and stare directly into the camera, but they are not endowed with speech. They do not speak, their eyes convey through the pantomime of the gaze the incarceration of the male ego. The final segment of the film is shot from a fixed-point perspective against the backdrop of a spring landscape, with a small pond flowing out of a rectangular dam and concrete culvert from which the water is transported serving as the establishing shot. Because the camera stays fixed continually on the landscape, the film takes on the qualities of a stage, a sort of arcadian amphitheater out of which numerous characters—couples—stroll in and out of frame as if in a dream sequence drawn from Akira Kurosawa's great film *Rashomon* (1950), which unfolds as a series of flashbacks. The slow pace of this final wordless segment of *Interior/Exterior, Full/Empty* is as beautifully realized as it is hauntingly ambiguous.

PROFILE/PROFILING

Since the interregnum that marked her shift from photography into film and video, Simpson has maintained a fairly constant interaction between photography and film. Each is used to augment the other, either as an extension of one (stills from films that are stand-alone photographic images) or in the interpretation of the other, or in conjunction. In any case, this has been fairly common practice in recent contemporary art. In 2001 Simpson embarked on a series of small black-and-white portraits shot in profile of single male and female combinations. These portraits are encased in white oval mats and arranged in repeating and alternating directions in an irregular grid formation. Two things are immediately striking in these series of images: the first

is the manner in which the figures photographed in profile recall the "racial typologies" of daguerreotypes of African slaves photographed by Louis Agassiz in 1850 in Columbia, South Carolina.[26] Though the profile has a long pictorial history, from Egyptian to Greek and Roman antecedents, and was broadly used for domestic portraiture in eighteenth-century paintings, with the rise of the human sciences in the nineteenth century it was adopted for more pernicious uses as a method for studying and categorizing criminality and racial inferiority. The profile was adapted as a method of study to discern alleged cranial deficiencies and irregularities in the features of criminals or anthropological subjects.[27] Philosopher Giorgio Agamben has engaged these developments in what he describes as the "anthropological machine." In the logic of modern scientific rationality, the anthropological machine "functions by excluding as not (yet) human an already human being from itself, that is, by animalizing the human, by isolating the nonhuman within the human…"[28] Profiling thus represents one of the pictorial functions of the anthropological machine. This merged the criminal and racial bodies and brought photography into alliance with anthropometry. For a long spell during the nineteenth century the reliance on this quack science magnified and extended the capability of the photographic apparatus in shaping the knowledge of "inferior" peoples.

In so doing, the profile portrait plunged from its sentimental perch on the domestic mantel down into the cauldron of racial and criminal laboratory. Simultaneously it invented an album of abnormalities and an archive[29] devoted solely to the study of racial types, the multiplication and indiscriminate isolation of the "nonhuman within the human." Between Alphonse Bertillon and Francis Galton—two prominent figures in the usage of anthropometry—the study of the cranial aspects of races and criminals was not only directed toward the biological, each was concerned with their effects on society. This is manifested in their methods and interest in how criminality and race impacts the social order. According to Allan Sekula, "where Bertillon was a compulsive systematizer, Galton was a compulsive quantifier. While Bertillon was concerned primarily with the triumph of social order over social disorder, Galton was concerned primarily with the triumph of established rank over forces of social leveling and decline."[30] Bertillon being French and Galton, English, I suppose this indicates the fundamental difference between the composition of French and English class systems. So much for science.

But the science of man in the nineteenth century, especially after the publication of Charles Darwin's *On the Origin of Species* in 1859, was a voracious and insatiable cannibal. Through the anthropological machinery of imperialism, it hunted and consumed in prodigious quantities the body of the other, in order to assure itself that the pseudo-scientific interest in racial otherness was not a sublimation of its own carnal abnormality. This brings me to the second point about my understanding of Simpson's idea to use the portrait profile convention, in the contemporary American practice of racial profiling. In these series of works, especially *Men* and *Study* (pp. 83–84) the combination of frontal and profile depictions underscores her intention to alert us to the connection between criminality and race. A similar device exists in Warhol's *America's Most Wanted* (1963).

Simpson's return to the historical exegesis of the black body is by now beyond annotation. It is informed by the constant interruption of aesthetics by ethics. Or rather the knotted relationship between the two, and in light of Wittgenstein's idea that "ethics and aesthetics are one and the same."[31] Yet, it needs stating that the recitation of the travails of the inflamed black body is really beside the point in this work on profiles and profiling. Rather, what Simpson is interested in is the social and cultural devices within which these two subjects are imbricated. The way they each speak to a larger social agenda, whether it be about immigration or terrorism, the uses of profiles and profiling have multiplied.

SHADOW ARCHIVE

In spite of its contemporary implication or because of it, Simpson addresses contestations that surround racial profiling and the issues they raise by recourse to a Foucauldian archaeology of the history of images of black people drawn from an archive that extends from the 1790s to the 1970s, from historic paintings to Hollywood dramas and blaxploitation films. Inscribed on the framed, demure photographs are the complete or partial titles (employed to magnify both their effect and meaning), drawn from films, paintings, and representations of and by black people, and arranged like a running list of citations or as encyclopedic entries that encode the sophistry of racial science. *Untitled (guess who's coming to dinner)* (p. 79) is both a title of one work and a subtext for its reading. Interspersed in the frame of this piece are vertical bands of near-identical profile shots of the same young black woman who is photo-graphed from back to side so as to make prominent—by a slight extension of the neck—the cranial features of her neck and slightly arched back. Arranged facing in and out of the frame, some of the images fill the oval frame or cut off part of the face. In the bottom left and right sides of the photographic panel runs a long vertical list of titles drawn from films and paintings. Whether the viewer remembers the films or paintings is not of interest; instead what seems to be taking place is the inscription through the listing of the titles, of a veritable shadow archive, one that is neither explanatory nor expository. Rather, the way the titles open up the space between image and history is epistolary in nature. In this way Simpson remains involved in her extended correspondence with the viewer about the way images signify and what sort of symptoms they point to. *Untitled (guess who's coming to dinner)* addresses the taboo interracial relationship in which Sidney Poitier plays the sensitive, urbane black love interest of a white woman. Needless to say, in the film Poitier has to overcome his blackness through his non-threatening demeanor (he plays a renowned United Nations doctor) in order to become worthy of his beloved in this romance of race and progressive politics. However, what is ultimately redeemed in the film is neither Poitier's black character nor blackness, but whiteness. These portraits are emotionally loaded, and historically acidic even though Simpson adopts the most innocuous form of outmoded imagery to explore the decadent discourse that envelops her subject.

FINAL THOUGHTS

I have written elsewhere that the black image is a troubled image; it perturbs the conscience, unsettles the tranquility of settled canons of beauty. Particularly in the museum context in which the aesthetic authority of art is often arbitrated, the black image is often seen first as an anomaly in the sense that it is foremost a political image before it could ever become a vessel for probing the epistemological fundaments of artistic tradition.[32] A portrait of a black person hanging in a museum is usually disturbing to viewers. Because it has historically resided marginally in the domain of the general imagination, except as a fugitive force—as Toni Morrison clearly shows— this figure is never wholly free of the reflexive assumption that it is outside of the norm of the canons of beauty. Therein lies the great incentive behind Simpson's prodigious complex analysis and usage of the black form in her work. Using a black subject in a work of art is neither a casual act nor innocent. To confer upon the black figure an aesthetic and historical value in artistic production is a consciously political act, one that does not in any way diminish the aesthetic value of the intention.

Nothing confirms this more than the manner in which generic blackness has functioned as a trope for negotiating the political and aesthetic in Simpson's work. Ignoring the political conditions of the black subject in art is a self-defeating act of critical bad faith. Along with this, Simpson has shown that the powers of recognition of this figure lie in the attendant compensatory erotic charge it produces. It draws viewers closer, often forcing new modes of recognition and identification. The unremitting monologues on identity and the self, the carefully calibrated discourses on race and gender, the contrapuntal nature of power and social consciousness in her work permit viewers to see the black subject afresh, in modes unfamiliar to their prior experience of it. Simpson asks viewers to engage her subjects not as coincidence but in conjunction with the aesthetic politics of American and Western devalorization of black identity. Her work suggests that politics and aesthetics are formed like Siamese twins. And to extricate their deformed joining requires the most delicate and dexterous surgery. In fact, it requires the complete suspension of belief in the idea that representation has a powerful impact in the formation of opinion about art. The anxiety of castration exhibited constantly by the black male confirms this. We see it in the misogynist acting out that often accompanies his performative public persona in pop culture, especially in sports and hip-hop culture.

The wounded black male figure could after all be recuperated. Simpson permits us to see this in *Cloudscape* (p. 100), a potent symbol of transcendence and grace. The solitary image of the black male figure whistling and enveloped by fog appears to be a song of departure from the charnel house of the racial sublime. But this does not mean it will disappear completely, since race and masculinity still have social meaning. However, we see that in recent years, the iconographical moorings of Simpson's work are increasingly being cloaked—never concrete nor in full display. Instead, they wear a different sort of covering, a kind of ethical camouflage that does not yield to easy deciphering. For more than twenty-five years Lorna Simpson's work has enriched the archive of American art, investing it with a complexity it has yet to return fully to viewers of contemporary art.

FOOTNOTES

1 Georges Didi-Huberman, *Invention of Hysteria: Charcot and the Photographic Iconography of the Salpêtrière*, trans. Alisa Hartz (Cambridge, MA: MIT Press, 2003), p. 63.

2 Simpson was twenty when she first exhibited these photographs in New York in 1980 while she was a student at the School of Visual Arts.

3 Edward Said, *Orientalism: Western Conceptions of the Orient* (London: Penguin, 1978). See also Malek Allaoula, *The Colonial Harem*, trans. Myrna Godzich and Wlad Godzich (Minneapolis: University of Minnesota Press, 1986).

4 In a recent conversation with the author, Simpson cites the seminal influence of this book on her work, particularly the interplay between Langston Hughes's poems and DeCarava's photographs.

5 See Cornell Capa, ed., *The Concerned Photographer*. This classic anthology of documentary photography was the catalogue of the exhibition organized by Capa in 1967 at the Riverside Museum. It introduced another term for documentary work that today may be perceived as tendentious.

6 See Kelli Jones, *(Un)Seen and Overheard: Pictures by Lorna Simpson* in *Lorna Simpson* (London: Phaidon Press, 2002), p. 47.

7 The seed of the changes that took place in Simpson's work were already planted in New York before she left for graduate school in San Diego. Simpson's exposure to the work of African American photographers such as Anthony Barboza, who were working experimentally and questioning the uses of photography, supported some of her attempts to formulate a new photographic strategy. At this time she met Carrie Mae Weems, who had organized a meeting of African American photographers in Just Above Midtown, a gallery focused on experimental and "avant-garde" work by black artists. This meeting helped in further clarifying Simpson's own doubts about documentary photography.

8 Ellen Ross, *Conversation: Ellen Ross with Cindy Sherman and Lorna Simpson*, in *Yard* (fall 2004), p. 22.

9 See Thelma Golden, *Black Male: Representations of Masculinity in Contemporary Art* (New York: Whitney Museum of American Art, 1994). This seminal exhibition and its accompanying book are perhaps the most thorough examination of the fate of the black male subject in visual culture.

10 Toni Morrison, *Playing in the Dark: Whiteness and the Literary Imagination* (New York: Vintage Books, 1992), pp. 6–7.

11 Ibid., p. 12.

12 See Frantz Fanon, *Black Skin, White Mask*, trans. Charles Lam Markham (New York: Grove Press, 1968). Please consult this work for all references. For additional insight into Fanon's thinking about liberation from colonial racism, see *Wretched of the Earth*, trans. Constance Farrington (New York: Grove Press, 1968). Fanon writes "The truth is that colonialism in its essence was already taking on the aspect of a fertile purveyor for psychiatric hospitals." P. 249.

13 See Michelle Wallace, *Invisibility Blues: From Popular Culture to Theory* (London and New York: Verso, 1990) and her reissued classic work *Black Macho and the Myth of the Superwoman* (London and New York: Verso, 1990).

14 See bell hooks, *Ain't I a Woman: Black Women and Feminism* (Boston: South End Press, 1981).

15 Ibid., p. 51.

16 Didi-Huberman, *Invention of Hysteria*, p. 8.

17 Ibid., p. 247.

18 Gilles Deleuze, *Difference and Repetition*, trans. Paul Patton (New York: Columbia University Press, 1994), p. 28.

19 Sigmund Freud, *The Basic Writings of Sigmund Freud*, ed. and trans. A. A. Brill (New York: The Modern Library, 1938), p. 380.

20 For a discussion of the film noir qualities of this group of works, see Jones, *(Un)seen and Overheard*.

21 Freud, *The Basic Writings*, p. 595.

22 Joan Copjec, *Imagine There's No Woman: Ethics and Sublimation* (Cambridge, MA: MIT Press, 2002), p. 159.

23 Fanon, *Black Skin*.

24 Ibid., see the essay *The Man of Color and the White Woman*, pp. 63–82.

25 Ibid., see the essay *The Woman of Color and the White Man*, pp. 41–62.

26 Brian Wallis, *Black Bodies, White Science: Luis Agassiz's Slave Daguerroetypes* in Coco Fusco and Brian Wallis, eds., *Only Skin Deep: Changing Visions of the American Self* (New York: International Center of Photography and Harry N. Abrams, Inc., 2003), pp. 163–81.

27 See Frank Spencer, *Some Notes on the Attempt to Apply Photography to Anthropometry during the Second Half of the Nineteenth Century,* in Elizabeth Edwards, ed., *Anthropology and Photography: 1860–1920* (New Haven and London: Yale University Press, 1992), pp. 99–107.

28 Giorgio Agamben, *The Open: Man and Animal*, trans. Kevin Attell (Stanford: Stanford University Press, 2004), p. 37.

29 See Allan Sekula's much discussed essay, *The Body and the Archive* in Richard Bolton, ed., *The Contest of Meaning: Critical Histories of Photography* (Cambridge, MA: MIT Press, 1989), pp. 342–88.

30 Ibid., p. 364.

31 Ludwig Wittgenstein, Tractatus, Logico-Philosophicus, Quoted in Hal Foster, *Prosthetic Gods* (Cambridge, MA: MIT Press, 2004), p. 56.

32 See Okwui Enwezor, *Haptic Visions: The Films of Steve McQueen,* in Gerrie van Noord, ed., *Steve McQueen* (London and Zurich: Institute of Contemporary Art, 1999), pp. 37–50.

conversation with the artist

ISAAC JULIEN AND THELMA GOLDEN
PREFACE BY SHAMIM M. MOMIN

_I_n this conversation, which took place on July 5, 2005, Thelma Golden, Director of the Studio Museum in Harlem, film and video artist Isaac Julien, and Lorna Simpson discuss aspects of Simpson's and Julien's work—primarily in film installation—that have evolved and shifted to align with their increasingly complex aesthetic and conceptual concerns. In their moving-image work each artist has moved toward a synthesis of formal exploration and socio-political critique, and each strives to embed this complexity within their use of the medium.

Seriality, fragmentation, simultaneous multiple viewpoints or screens—even the arrangement of their works, photographic or filmic, within an installation context itself—evoke questions about the linearity of time and the ways in which personal and historical memory tends not to follow this progressive path. Simultaneity of images, circularity of cinematic time, and moments of unexpected emptiness and pause become means to present a psychological interiority that troubles a neat, hermetic reading of narrative or subject. Reflecting a need to advance beyond the flattening of meaning and interpretation that occurs in "identity politics," the work literally and figuratively moves past the notion of a single frame within which a viewer's expectation of cinematic narrative is played out. By avoiding a complete, and thus fixed, representation of character, type, or even place within the works themselves, what Simpson calls the "gaps and contradictions" allows for a more open reading of the works overall, one that reflects more truly the multivalent experience of contemporary life.

Both Simpson and Julien embrace a multiplicity of narrative perspectives that problematizes the viewer's position as an individual subject. While this is a strategy used in much narrative filmmaking to build suspense or atmosphere, both artists deliberately call attention to these shifts rather than attempting to mask the transitions into a seamless experience. Though they employ different practices to achieve this, each loop/fragmented image/multiple screen further denies cause and effect, undermining the linearity of the narrative, and enhances the viewer's role in identifying meaning. Disallowing a complete immersion in the work thus holds the viewer in a position of self-awareness in relationship to it, the same kind of reflexive troubling of expectations that occurs within the content of the images.

In ancient Greece, art was said to provide ekstasis, which essentially means "to be outside ourselves." However unnerving this experience might be, these shifted perspectives offered by both Simpson's and Julien's work provide a chance to achieve that ecstatic position in its original sense, and to look back at ourselves.

SHAMIM M. MOMIN

THELMA GOLDEN: I think an interesting place to start would be with the ways you both have approached similar media differently—Isaac, in your work beginning in film, moving into video and film installation, and including photography; and Lorna, in your photography, moving into video and film installation, and looking forward to film.

LORNA SIMPSON: There is something about working in film and video that caused me to shift the way that I work with regard to process. Film provides a multilayered process— coming up with different ideas that then get played out in production fairly quickly or at the last minute or are planned and scripted—as opposed to the solitary act of making photographs. For me, film provides an option for a much more spontaneous way of working.

I have always been captivated by the allegorical narrative that infuses your work, Isaac, and by the way you keep the narrative structure nonlinear and open-ended.

ISAAC JULIEN: Interestingly, I've always been very inspired by photography and in particular by your photographic work, Lorna. Your concern for a photographic language translates to questions about "time," so I think of you in your early work as being interested in the moving image and photographs even as "film stills." The question of "time" has developed very strongly in your photography; certainly the seriality of the later photographic works lends itself to an inquiry about narrative and multi-temporality.

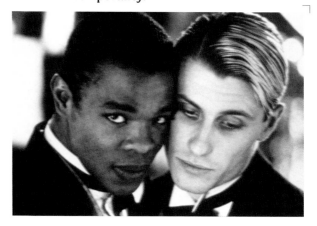

In your work, those concerns developed into moving images, whereas my interest in photography led to making films, in a reversal movement from your development. If I think about *Looking for Langston* [Julien's 1989 film about the poet Langston Hughes], for example—where my use of black-and-white photography is in fact an homage to photographers like James Van Der Zee [1886–1983]—and then if I think about some of your later work in black-and-white, I can see we shared concerns about, say, film noir.

Your work is embedded in the history of conceptual art photography—such as that by Victor Burgin, Mary Kelly, and John Baldessari—which borrows from postmodernist concerns about conceptual art—a dialogue between a conceptual kind of photography with cinematic references. I see that as an important trajectory in your overall work.

ISAAC JULIEN
from *Looking for Langston*, 1989
16mm black-and-white film
40 minutes, sound
Courtesy the artist and Victoria Miro Gallery

LORNA SIMPSON: It is true that the structural format of the work most often pulled toward the serial, implying a time-based structure. What I've tried to do with the photo work is create contradictions—an edge between the subject and the interpretation about how a "subject" is viewed or contextualized.

Film opened up this whole other framework in which to tweak that—to try to challenge viewers in terms of what they expect to see. For instance, I found the effect on the audiences at the private screenings of *Looking for Langston* (before it was released in the States)—while they were seated in a quiet, dark room—to be amazing and quite

instructive. And at the same time I was getting to know the work of and meeting Marlon Riggs and introducing his work *Tongues Untied* [1990] in a film and video course I was teaching. While these works are quite different in subject and approach, they both use poetry/prose as the mode of narrative discourse. I was impressed by how two different works on the subject of black gay identity created such an uproar and led to right-of-use issues with Langston's estate, and to Marlon's difficulty with *Tongues Untied* being played on PBS stations outside of New York City before midnight.

I found the legal and structural issues that arose in the screening of *Langston*, and the decision that sequences with texts by Langston were to be omitted and edited into silent sequences, incredibly instructive about the evolution of making a work. It was a meditation on a life, but the imposed censorship allowed the film to structurally sharpen its reflection of that life and the context of life now. Definitely an outside-the-film-box decision.

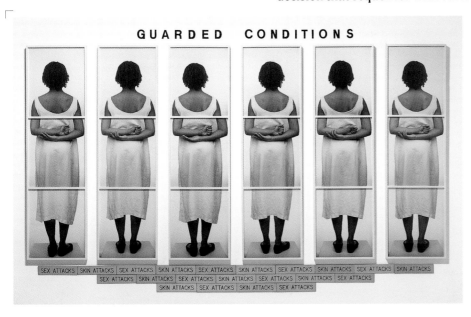

LORNA SIMPSON
Guarded Conditions, 1989
18 Polaroid prints, 21 engraved plastic plaques,
plastic letters
91 x 131 inches overall
Museum of Contemporary Art, San Diego; Museum
purchase, Contemporary Collectors Fund

THELMA GOLDEN: In some ways, you each touch on issues of identity and the body in your work. The way these are understood creates a space in which we as viewers can understand how iconic those works are. I've always seen a correspondence between *Looking for Langston* and *Waterbearer* [p. 15] in terms of the response they received—they occupy similar places in terms of their iconicity in thinking about certain issues. Can you each talk about the way you've worked around these issues, both in the early works and then moving forward? For example, Isaac, your most recent work, *Fantôme Créole* [2005], is going to receive a similar response, because it takes a subject and twists it in ways that I'm not sure the audience is quite ready for.

ISAAC JULIEN: Issues about audience always arise when artists are working with subject matter that is pertinent to a community's or region's self-image, as in *Fantôme Créole*; but then that's why one makes art—to push the boundaries—and that's what was so exciting for me initially in seeing Lorna's work. I remember being fascinated by *Wigs* (p. 39–41), for example, and reading Kobena Mercer's essay on "hairstyle politics"; within *Wigs* you had a kind of visual exploration or meditation on some of those themes, and I have always wondered, Lorna, if you had perhaps been in dialogue with Mercer's text since these debates had been actualized by what some called "black British cultural studies."

Similarly, when I saw your large-scale photographic works—like *Staircase* [1998] and *Fire Escape* [1995]—I remember thinking again about cinema and the politics of space as an invitation for us to meditate on architecture. Then again, even with some of your earlier works, like *Guarded Conditions*, I thought about the cinematic seriality of the work in terms of the image and the mise en scène that gets created as you look at the work and walk past it—with the repetition of the image producing

different meanings *en passage.*

I was very excited about the linguistic play around ideas of race in some of these works. I saw that as a response to conceptual art practice, which was then fairly Eurocentric—the conceptual art practice that was taking place in the '80s—and the way women and black artists were taking up ideas of identity and postmodernism. Lorna, your work was giving that a twist, re-reading questions of sexual difference and interpolating them with complex questions of race in the visual field.

There was also a preoccupation with questions of self-identity, specifically with the black self-image and how that is projected. It's the way these things are put together that creates this very nuanced and exciting re-reading of the history of conceptual art, and they're the kinds of things that I hoped to perform as well in pieces like *True North* [Julien's 2004 video installation about the black manservant Matthew Henson (pp. 140—41) and *Fantôme Créole.*

One is essentially looking at a particular historical figure and then giving that a twist—the protagonist in *True North* is not a man, but a woman, a black woman in fact. It's sort of a meditation on that journey but obviously with references to work shot in Africa. In *Fantôme Afrique* [2005]—which brings those two pieces together under the title *Fantôme Créole*—it's really about the creolization of those narratives and spaces and making one story or repertoire of images from that arctic space collide against the other, an African space.

It is very much about utilizing an avant-garde sensibility, and I've been struck by that preoccupation in your work, Lorna. That makes me think about *Corridor* [see pp. 90—91], a beautiful work in which the very careful framing of the movements performed by the two protagonists reflects the presence of a cinematic photographer's eye.

The performance is formed by the two protagonists, the one in the Coffin House and the other in the Gropius House. A tension results from the way the musical scores are juxtaposed with the images, which parallel mirror actions that create a mise en scène and tension between the two historical images. This becomes a formal suturing together of historical questions connected to racial understanding of time and displacement. It's in the above examples that I see a strong connection between my aesthetic conceptual concerns and Lorna's.

LORNA SIMPSON: *Corridor* opposes two important historical dates in American history, 1860 and 1960, to reflect upon the state of things at those crucial points and also to foreground what might be the psychological disposition of the characters portrayed—because nothing specific happens at the moment they are portrayed. Isaac, it's interesting that you have stretched this premise further by including scenes from *True North* in *Fantôme Créole*— an erasure of the boundary of one specific subject and/or filmic sequences that are confined to an original work. This creates an unbroken, continuous meditation over several works, and different contexts are proposed.

THELMA GOLDEN: Isaac, you were talking about *Fantôme* and *True North* and the way you created them separately. Doesn't *Fantôme* include some of the *True North* imagery?

ISAAC JULIEN: That's right, yes.

THELMA GOLDEN: Isn't that similar to what you did with *Conservator's Dream* [1999] and *Vagabondia* [2000]?

ISAAC JULIEN: Yes, in a way. I was thinking of multitemporality— different times, different locations juxtaposed against one another—as a connection to some of the themes in *Corridor*, where you have different historical times signified by architectural surroundings and also by the costumes and the way in which both those subjects are directed to move to underline their historical specificity. This is obviously connected to questions around memory and race, creating a certain mood.

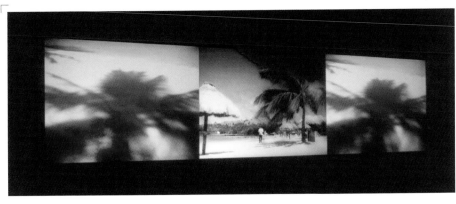

ISAAC JULIEN
from ***Paradise Omeros***, 2002
Triple DVD projection, 16mm film transferred to DVD
20 minutes, 29 seconds
Installation: Documenta 11_Platform5:
Ausstellung/Exhibition, Binding Building, Kassel, Germany
Courtesy the artist and Victoria Miro Gallery

THELMA GOLDEN: There also seems to be a correspondence between *Corridor* and *Paradise Omeros* insofar as both works span historical moments that are not indicated just by dress or action. I think there's an interest on both of your parts in looking at historical moments and moving them into the work around image, sound, and narrative in a nuanced way.

ISAAC JULIEN: Yes, in terms of this preoccupation it's very interesting to see what the philosopher Gilles Deleuze [1925–1995] might call the "time image" in relationship to the notion of expanded time—which one sees in a work like Chantal Ackerman's film *Jeanne Dielman* [1975], where in fact nothing happens but there is this formal concentration. It's through that formal concentration that you begin to unpack a psychological environment that is communicated through the gestural interiority of the characters and by the camera movement, through performance and duration. These minimal gestures create a space for meditation on the symbolic meaning these actions are communicating, such as an internal psychic conflict brought on by historical events. That's not to say that because the subject in a piece of work is black that the work is necessarily burdened by all these questions, but the weight of history does haunt these aesthetic visual inquiries.

I remember reading an interview in the Phaidon book [*Lorna Simpson*, 2002] with the two of you in which you, Lorna, speak about the compulsion to repeat and how this is something you want to avoid. You also said this was behind your move toward exploring some of these themes in other mediums, such as film and audio-visual installations, and that that was important in terms of keeping your own interests and sense of experimentation alive. And for me, it was very important to move away from film proper into a gallery context because those same concerns were at stake in my own practice—to keep it alive I needed to change, because for me there's the idea that in an art context you can experiment and have sort of formal, aesthetic concerns that could be foregrounded. In cinema proper, that became less and less of a possibility in the late '90s.

THELMA GOLDEN: Perhaps this is where you both converge. Through this move to film, Lorna is claiming more space, and it was through your move into art gallery practice that you claimed more space.

ISAAC JULIEN: Absolutely.

LORNA SIMPSON: I guess the thing that I fear for my own work is losing the tension that comes with experimentation. That is what makes the process so interesting.

The complexity of characters parallels the complexity of the way I put the pieces together. I want to avoid works that are just two-dimensional or easily read in the sense that as you're watching you think you get all the details and that's the end of the story. I prefer gaps and contradictions so that not all the viewer's questions are answered. In the narrative pieces, with text, I've always wanted to keep that open so as not to nail down a monolithic type or character within works.

In your work there's a concerted effort to keep the viewers' location open as they try to see themselves. And you have a way of presenting characters and situations without providing a soft landing. The characters are not one-dimensional. There's always this complexity and contradiction—doubling or tripling, literally—that occurs throughout.

ISAAC JULIEN: That's really been a concern, and it comes out of a distancing from the things we ordinarily see in a moving-image culture where we have narrative, character, and plot—we identify and then we know the interiority of that character, and then in a way there's no enigma. We try to create protagonists who have an enigmatic quality, and that enigmatic quality is precisely about not necessarily telling the viewer or the audience everything about that character, or in narrative terms not fulfilling all those conventional kinds of normative narrative expectations.

These concerns are both practical and Bressonian— because Bresson [French director Robert Bresson, 1901–1999] spoke about his actors being models and about not wanting the actors to act but rather to be themselves, so to speak. This has always been an appealing idea for me because I think performance and performativity, when it's not acted in the more traditional sense, allows for a more open way of reading the characters. Of course, sometimes that can also be conceived of as being deliberately confusing or unconventional, but that unconventionality is important because that's where one starts to build a language or unique vocabulary for trying to espouse different nuances and indeed, hopefully, to produce different readings. I was thinking about that in *31* [see pp. 88–89], the piece you did for Documenta 11 in Kassel, which had a unique representation of a female protagonist whom we were able to witness at several daily routines at once—presented like a time capsule.

I remember thinking about the complexity of the daily actions that one performs and thinking about subjectivity and complexity in those various performances, and about having these images presented on thirty-one screen monitors. That was really very interesting, because this visual strategy would be very different from the ones we see in popular culture, in popular media; hence it would seem to me that it becomes very important that there are different spaces for identification of, say, a black woman

138

i n 1965, Jean-Luc Godard released *Pierrot le Fou*, his tenth feature film. Shortly after its premiere, *Cahiers du Cinéma* conducted an interview with the director, in which he declared that with *Pierrot*, he "wanted to tell the story of the last romantic couple." As played by Jean-Paul Belmondo and Godard's then wife, the actress and singer Anna Karina, this "last romantic couple" represented two aspects of being: action and reflection. Belmondo (as Pierrot) keeps a journal, while Karina (as Marianne Renoir) creates various theaters of play, largely in or around nature. But, in one striking sequence, the couple is tucked away in an ugly modern flat, presumably somewhere in or near Paris. There, we see them at the beginning of their love. As Karina goes about the apartment, playing house—that is, brewing her lover's coffee, serving the coffee, and then donning a white sleeveless dress, all the while singing a charming little song of amour—Belmondo lies in bed, perhaps unaware that as Karina tries to make their makeshift dwelling more of a home, she has also stepped over a dead body in the sitting room. She does not speak of it.

In this scene, Godard treats that dead body—treats violence—as furniture, another object or casualty to live with as one goes about the business of being active or reflective. (Indeed, Godard resisted any interpretation about the violence in *Pierrot*. When, in the *Cahiers* piece, the interviewer suggests that there is a lot of blood in the picture, Godard insists that one could view the blood as a lot of red.)

Godard does not go on to explain what that dead body "means." It is up to us— the audience watching Belmondo and Karina in the act of performing—to think and feel as we like about death, just as we must think and feel what we like about these lovers who discuss, among other things, the Tet offensive, Abbott and Costello routines, and various advertising slogans. While Pierrot and Marianne may be the last romantic couple, that does not preclude their being a distinctly modern one as well. (Generally, we assume that romanticism and modernism cannot coexist, modernism being about the real, and romanticism not. Godard proves otherwise. He examines the soft heart at the center of reason.) Pierrot and Marianne could not exist outside of cinema, because cinema has created them. Newsreels, musicals, documentaries, tearjerkers— Godard references most of cinema's various genres so that Pierrot and Marianne may exist. In turn, they live the only lives they know how: lives shaped by the dreams and expectations that cinema projects ceaselessly, hungrily, rapturously.

Once Pierrot gets out of bed and finishes dressing, we are in a different kind of

movie altogether—or, rather, a movie that we could not have predicted. For Pierrot and Marianne's love began under the most trite or commonplace circumstances possible: They had an affair sometime before the start of the film; Pierrot has grown bored with his settled, bourgeois life; Marianne is a way out. But, just as we grow accustomed to that movie—a movie of misbegotten love—Godard shifts the narrative, shifts our perspective. We see Pierrot adjusting his tie and casually discovering a few more dead bodies in the apartment. We are in Z-land then—in a political thriller. And, just as suddenly, Pierrot and Marianne are on the road, on the run, on the lookout for a place to coexist outside of death.

Twenty-three years after *Pierrot le Fou*, Godard began to construct his monumental *Histoire du Cinéma*. In that film, there appears this legend: "Cinema has always been the act of white boys showing off for other white boys." Would *Pierrot le Fou* have become a "thriller"—no matter how briefly—had the title character not seen those dead bodies—the same dead bodies that Marianne so decorously circumvents in her bid to

Excerpts from a document written and assembled by Jean-Luc Godard alongside *Histoire(s) du Cinéma* (1988–97): "Toutes les Histoires" and "Une Histoire Seule."

make a home in that ugly Parisian flat? In other words, does Pierrot's whiteness, maleness, and need to "show off" the power of both account for his taking action, even though his white, male adversaries are dead? And what is Pierrot—Godard—showing by "rescuing" Marianne from this thrilling cinema of red and unexplained corpses? Marianne never indicates that she needs to be saved. But she is a woman, and so is born to be incorporated into the distinctly male ambition to protect and serve a female, who is then bound to saying his name in exchange for her rescue, something she may not have asked for in the first place.

CINEMA HAS ALWAYS BEEN THE ACT OF WHITE BOYS SHOWING OFF FOR OTHER WHITE BOYS.

Photographs do not speak, but they can speak volumes about what the photographer means them to say about his or her subject, living and breathing and dying in the frame. But the best or most arresting photographs deny instant or even considered verbalization; they shut us up, just as Pierrot shuts up in the face of Marianne's cinematic being. In a career now spanning nearly twenty-five years, Lorna Simpson has created a gallery of Marianne Renoirs, sometimes seen in multiples, sometimes standing or sitting alone in a single frame,

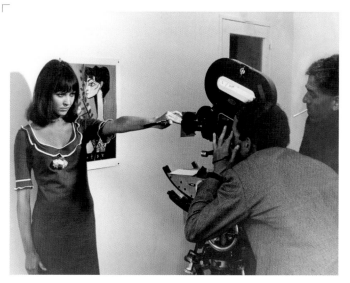

Anna Karina (as Marianne Renoir)
on the set of *Pierrot le Fou*

faceless. That Simpson insists on her female subjects being absolutely still in her photographs and, at times, in her recent video work, is a bit of direction that positions her work closer to cinema, which is composed of single frames, too. And, as viewers of her work know, Simpson is resolute in her belief in, and collaboration with, the frame—be they frames that move or not. But no matter the genre, Simpson's images are linked to the cinema in what they convey to the viewer ceaselessly, hungrily, rapturously.

While Godard proclaimed the cinema to be the truth at twenty-four frames per second, Simpson first set out to explore the truth at one or two or twelve frames, isolated on a wall, not to be looked at for just a second. And what was the overall "truth" to be gleaned from these individual frames? Individual truths. That the woman represented in one part of a sequential piece was not, figuratively speaking, the same woman who appeared in the next frame, largely because of the shift in the photographer's perspective, not to mention the subject's own. Rarely if ever do we know, in a Simpson photograph, what the subject is thinking. While the majority of Simpson's photographs can be classified as portraits—that is, Simpson photographs people, or some aspect of personhood, such as a coil of hair or a white shift—the photographs reject the portraitist's traditional role: to tell us something about the person being photographed. Instead, Simpson prefers to exercise the rights of the auteur, sometimes going as far as applying writing over some part of her subject's face, as in *Proof Reading* (p. 27). The piece is striking in its Godardian use of letters not only as a graphic element, but also as a visual element that says as much about the character under review as the face we cannot see, the face that the words obscure.

Words as characters. Who can forget Pierrot's opening credits, wherein Godard fills the screen, rather slowly, with vowels and then consonants? The letters—supported by a soundtrack—are given as much credence as our Pierrot, our Marianne, who sometimes speaks with the halting beauty of people who not only grew up reading subtitles, captions under newspaper photographs, comic book dialogues, but live having to find some kind of meaning amid all that junk.

Born in 1960, Simpson belongs to that generation of artists who were inspired as much by film—read Godard—as by the other plastic arts. To direct is to love the object under review, as well as a desire to dissect "her," since the most arresting cinema-objects are women, known and unknowable all at once, just like Marianne. And how did Simpson find her various Mariannes, all those black girls saying everything and nothing? By locating what she could love in them, but from behind the camera. Cinema-objects

are created as much by a director's love for the person moving this way and that as by the object's self-love and need to project something of that self-love to the camera.

A common misconception surrounding Simpson's work is that because her photographs and videos feature black women, or the physical aspects of black female-ness—braids and so on, as in her 1989 piece *Memory Knots*—that the characters represented are "oppressed" or "dominated" by the quotidian—that is, the white boys who define cinema. But Simpson's Mariannes replace those cinema boys as the center of our attention. Simpson's women reflect out into the world with their own language and power. Simpson's women are the love objects she places center frame because they are central to her, and her need to direct them, too.

Words, faces, bodies—these are the essential building blocks one must use to create a narrative about being, which in the end is cinema's only story. As in her early photographs, Simpson's videos reinvent the moving image by reducing that image to its essence: a woman's face, body, a chair. One can detect Godard's influence here. Simpson may shoot a woman's shoe as a woman's shoe, but it has a history too: the history of that absent woman who wore that shoe in the world somewhere, seeking her own language, without Pierrot. Simpson would probably agree with Godard's view that blood could just be red, except for the fact that Simpson works primarily in black-and-white, the colors one associates with words on a page, documents, Liz and Monty in closeup in *A Place in the Sun*: faces that represent the fact of love.

In Simpson's 2004 video *Blue to Black* her "dialogue," such as it is, is flat, emotionless. The emotion to be found here is in watching a woman move in space—Marianne drifting from room to room, restless in the prison and freedom of the soul. Where is Simpson's Marianne going? To the edge of the frame, pushing Simpson beyond reason, testing her control as director, and leading the way to the split-screen effect Simpson has employed in her cinema work. Simpson intends for us to know that the split screen shows us something about the split between action and reflection, maleness and femaleness, drama and documentary, Pierrot and Marianne.

In his 1891 essay "Pen, Pencil, and Poison," Oscar Wilde remarked:

> *It has constantly been made a subject of reproach against artists and men of letters that they are lacking in wholeness and completeness of nature. As a rule this must necessarily be so. That very concentration of vision and intensity of purpose which is the characteristic of the artistic temperament is in itself a mode of limitation to those who are preoccupied with the beauty of form. Nothing else seems of much importance.*

146

1999

The American Century: Art and Culture, 1950–2000, Whitney Museum of American Art, New York.

Regarding Beauty: A View of the Late Twentieth Century, Hirshhorn Museum and Sculpture Garden, Smithsonian Institution, Washington, D.C.

Selections from the Art Institute of Chicago: African Americans in Art, The Art Institute of Chicago.

1998

The Hugo Boss Prize 1998, Solomon R. Guggenheim Museum Soho, New York.

InSite '98: Mysterious Voyages: Exploring the Subject of Photography, Contemporary Museum, Baltimore.

PhotoImage: Printmaking 60's to 90's, Museum of Fine Arts, Boston. Traveled to the Des Moines Art Center, Iowa.

1997

Deslocações: From Here to There, Fundação Calouste Gulbenkian, Lisbon, Portugal. Traveled to Centro Português de Fotografia, Porto, Portugal.

Evidence: Photography and Site, Wexner Center for the Arts, The Ohio State University, Columbus. Traveled to the Cranbrook Art Museum, Bloomfield Hills, Michigan; The Power Plant, Toronto, Ontario, Canada.

From Body to Being: Reflections on the Human Image, Des Moines Art Center.

inSITE 97, San Diego.

Trade Routes: History and Geography: Life's Little Necessities: Installations by Women in the 1990s, Second Johannesburg Biennale, South Africa.

1996

Bearing Witness: Contemporary Works by African American Women Artists, The Spelman College Museum of Fine Art, Atlanta. Traveled to the Fort Wayne Museum of Art, Indiana; the Polk Museum of Art, Lakeland, Florida; The Columbus Museum, Georgia; African American Museum, Dallas; the Minnesota Museum of American Art, St. Paul; The Gibbes Museum of Art, Charleston, South Carolina; The Edwin A. Ulrich Museum of Art, Wichita State University, Kansas; the Portland Museum of Art, Maine; The Museum of Fine Arts, Houston; African American History and Culture Museum, Fresno, California.

Gender Beyond Memory: The Works of Contemporary Woman Artists, Tokyo Metropolitan Museum of Photography, Japan.

Thinking Print: Books to Billboards, 1980–1995, The Museum of Modern Art, New York.

Urban Evidence, The Cleveland Center for Contemporary Art.

1995

Longing & Belonging: From the Faraway Nearby, SITE Santa Fe.

1995 Biennial Exhibition, Whitney Museum of American Art, New York.

Outburst of Signs, Kunstlerwerkstatt, Munich, Germany.

Traces: The Body in Contemporary Photography, The Bronx Museum of Art, New York.

1994

Bad Girls West, UCLA Wright Art Gallery, Los Angeles.

Black Male: Representations of Masculinity in Contemporary American Art, Whitney Museum of American Art, New York.

90–70–90, Tel Aviv Museum.

Wigs, The Museum of Photographic Arts, San Diego.

1993

1993 Biennial Exhibition, Whitney Museum of American Art, New York.

Personal Narratives: Women Photographers of Color, Southeastern Center for Contemporary Art, Winston-Salem, North Carolina.

PROSPEKT 93, Frankfurter Kunstverein and Schirn Kunsthalle, Frankfurt, Germany.

1992

Überleben, Bonner Kunstverein, Bonn, Germany.

Bridges and Boundaries: African Americans and American Jews, organized by The Jewish Museum, New York. Traveled to the University Gallery, University of Massachusetts, Amherst; the National Civil Rights Museum, Memphis, Tennessee; the Muscarelle Museum of Art, The College of William and Mary, Williamsburg, Virginia; Atlanta History Center, Atlanta, Georgia.

Devil on the Stairs: Looking Back on the Eighties, Institute of Contemporary Art, University of Pennsylvania, Philadelphia. Traveled to the Newport Harbor Art Museum, Newport Beach, California.

Dirt and Domesticity: Constructions of the Feminine, Whitney Museum of American Art at Equitable Center, New York.

HAIR, John Michael Kohler Arts Center, Sheboygan, Wisconsin.

Images Metisses, Arab World Institute (IMA), Paris.

Trans-Voices, The American Center, Paris, in collaboration with the Public Art Fund, New York, and the Whitney Museum of American Art, New York.

1991

Beyond the Frame, Setagaya Art Museum, Tokyo. Traveled to The National Museum of Art, Osaka, Japan; Fukuoka Art Museum, Fukuoka, Japan.

1991 Biennial Exhibition, Whitney Museum of American Art, New York.

Places with a Past: New Site-Specific Art at Charleston's Spoleto Festival, Spoleto Festival U.S.A., The Gibbes Museum of Art, Charleston, South Carolina, and the City of Charleston.

The Sibylline Eye, Munich Kunsthalle, Munich, Germany.

Word as Image: American Art 1960–1990, Contemporary Arts Museum, Houston.

1990

The Venice Biennale, Aperto '90, Arsenale, Venice.

Autoportraits, Camerawork, London.

AVA 9, New Orleans Museum of Art. Traveled to the Southeastern Center for Contemporary Art, Winston-Salem, North Carolina; Fogg Art Museum, Harvard University Art Museums, Cambridge, Massachusetts.

The Decade Show: Frameworks of Identity in the 1980s, Museum of Contemporary Hispanic Art, New York; New Museum of Contemporary Art, New York; The Studio Museum in Harlem, New York.

1989

Constructed Images: New Photography, The Studio Museum in Harlem, New York. Traveled to Foto Fest, Houston; Berkeley Art Museum, University of California; the High Museum of Art, Atlanta, Georgia; the Baltimore Museum of Art.

Image World: Art and Media Culture, Whitney Museum of American Art, New York.

Prisoners of Image 1800–1988: Ethnic and Gender Stereotypes, The Alternative Museum, New York.

1988

Autobiography: In Her Own Image, Intar Gallery, New York. Traveled to the Nexus Contemporary Art Center, Atlanta, Georgia; the Mills College Art Museum, Oakland, California; and the Ritter Art Gallery, Florida Atlantic University, Boca Raton, Florida.

The BiNational: American Art of the Late 80's/German Art of the Late 80's, Museum of Fine Arts and Institute of Contemporary Art, Boston. Traveled to Städtische Kunsthalle, Kunstsammlung Nordrhein-Westfalen, and Kunstverein für die Rheinlande und Westfalen, Düsseldorf, Germany; Kunsthalle Bremen and Gesellschaft für actuelle Kunst, Bremen, Germany; Wurttembergischer Kunstverein, Stuttgart, Germany; Ateneum, Helsinki, Finland.

Messages to the Public, Spectracolor Lightboard, Times Square, New York.

Utopia Post Utopia, Institute of Contemporary Art, Boston.

1987

The Castle, installation by Group Material, Documenta VIII, Kassel, Germany.

Large As Life: Contemporary Photography, Henry Street Settlement, New York. Traveled to the Jamaica Art Center, New York.

9 Uptown, Harlem School of the Arts, New York.

The Studio Artists, The Clocktower, New York.

1986

Three Photographers: The Body, New Museum of Contemporary Art, New York.

1985

Seeing is Believing? Photo Generated Artworks, The Alternative Museum, New York.

1983

Contemporary Afro-American Photography, Allen Memorial Art Museum, Oberlin College, Ohio. Traveled to the University Center, Delta College, Detroit; the Chicago Public Library & Cultural Center, Chicago; the Weatherspoon Art Gallery, University of North Carolina, Greensboro; the Colgate University Art Collections and the Picker Art Gallery, Hamilton, New York; The Mary Lou Williams Center for Black Culture, Duke University, Durham, North Carolina.

selected bibliography

BOOKS, EXHIBITION CATALOGUES, AND BROCHURES

Armstrong, Richard. *1991 Biennial Exhibition*. Exhibition catalogue. New York: Whitney Museum of American Art, 1991.

Centric 38: Lorna Simpson. Exhibition brochure. Long Beach: University Art Museum, California State University, 1990. Text by Yasmin Ramirez Harwood.

Converge. Miami: Miami Art Museum, 2000. Exhibition catalogue. Text by Thelma Golden.

Enwezor, Owkui, et al. *Documenta XI*. Exhibition catalogue. Ostfildern-Ruit, Germany: Hatje Cantz, 2002.

Fernández-Cid, Miguel, and Marta Gili. *Compostela: Lorna Simpson*. Exhibition catalogue. Santiago de Compostela, Spain: Centro Galego de Arte Contemporánea, 2004.

Gili, Marta, et al. *Lorna Simpson*. Exhibition catalogue. Salamanca, Spain: Centro de Arte de Salamanca, 2002.

Hartman, Saidiya V., and Beryl J. Wright. *Lorna Simpson: For the Sake of the Viewer*. Exhibition catalogue. New York: Universe Press and Chicago: Museum of Contemporary Art, 1992.

Heon, Laura Steward, et al. *Yankee Remix: Artists Take on New England*. Exhibition catalogue. North Adams, Massachusetts: MASS MoCA and Boston: Society for the Preservation of New England Antiquities, 2003.

The Hugo Boss Prize.1998 [Douglas Gordon, Huang Yong Ping, William Kentridge, Lee Bul, Pipilotti Rist, Lorna Simpson]. Exhibition catalogue. New York: Guggenheim Museum Publications, 1998.

I'm Thinking of a Place. Exhibition brochure. Los Angeles: UCLA Hammer Museum, 2001. Text by Lisa Henry.

Jacob, Mary Jane, et al. *Places with a Past: New Site Specific Art at Charleston's Spoleto Festival*. Exhibition catalogue. New York: Rizzoli International Publications, Inc., 1991.

Jones, Kellie, Thelma Golden, and Chrissie Iles. *Lorna Simpson*. London: Phaidon Press Limited, 2002.

Lorna Simpson. Exhibition brochure. New York: Josh Baer Gallery, 1989. Text by Kellie Jones.

Lorna Simpson. Exhibition brochure. Hamilton, New York: The Gallery of the Department of Art and Art History, Colgate University, 1991. Text by Coco Fusco.

Lorna Simpson. Exhibition brochure. Elkins Park, Penn.: Tyler School of Art Galleries, Temple University, 1992. Text by Cheryl Gelover.

Lorna Simpson. Exhibition brochure. Vienna: Wiener Secession, 1995. Text by bell hooks.

Lorna Simpson. Exhibition brochure. Wooster, Ohio: The College of Wooster Art Museum, 2004. Text by John Siewert.

Lorna Simpson: Call Waiting. Exhibition brochure. Toronto: Art Gallery of Ontario, 1998. Text by Michelle Jacques.

Lorna Simpson: Photoworks and Films, 1986–2002. Exhibition brochure. Dublin: Irish Museum of Modern Art, 2003. Text by Brenda McParland and interview by Thelma Golden.

Lorna Simpson: Standing in the Water. Exhibition brochure. New York: Whitney Museum of American Art at Philip Morris, 1994. Interview by Thelma Golden.

Molesworth, Helen, et al. *Image Stream*. Exhibition catalogue. Columbus, Ohio: Wexner Center for the Arts/The Ohio State University, 2003.

Perspectives 15: Lorna Simpson. Exhibition brochure. Portland, Oregon: Portland Art Museum and Oregon Art Institute, 1990. Text by John S. Weber.

Projects 23: Lorna Simpson. Exhibition brochure. New York: The Museum of Modern Art, 1990. Text by Jennifer Wells.

Rinder, Lawrence R., et al. *2002 Biennial Exhibition*. Exhibition catalogue. New York: Whitney Museum of American Art, 2002.

Robinson, Jontyle Theresa, et al. *Bearing Witness: Contemporary Works by African American Women Artists*. Exhibition catalogue. New York: Spelman College and Rizzoli International Publications, 1996.

Ross, David A. and Jürgen Harten. *The Binational: American Art of the Late 80's, German Art of the Late 80's*. Exhibition catalogue. Boston: The Institute of Contemporary Art and Museum of Fine Arts; Cologne: DuMont Buchverlag, 1988.

Scenarios: Recent Work by Lorna Simpson. Exhibition brochure. Minneapolis: Walker Art Center, 1999. Text and interview by Siri Engberg and Sarah Cook.

Simpson, Lorna, and Sarah J. Rogers. *Lorna Simpson: Interior/ Exterior, Full/Empty*. Exhibition catalogue. Columbus, Ohio: Wexner Center for the Arts/The Ohio State University, 1997.

Willis, Deborah. *Lorna Simpson: Untitled 54*. Exhibition catalogue. San Francisco: The Friends of Photography, 1992.

Wolff, Sylvia. *Focus: Five Women Photographers*. Morton Grove, Ill.: Whitman & Co., 1994.

PERIODICALS

Als, Hilton. "Def in Venice: Fear and Loathing at the Biennale." *Village Voice*, July 17, 1990, p. 41.

Arango, Jorge. "At Home with Lorna Simpson." *Essence* (May 2002): 172–74, 177.

Artner, Alan G. "Spare Power: Simpson's Simplicity Yields Weighty Social Comment." *Chicago Tribune*, November 22, 1992, pp. 12–13.

Aukeman, Anastasia. "Lorna Simpson at Sean Kelly." *ARTnews* (January 1996): 124.

Avgikos, Jan. "Lorna Simpson at Josh Baer Gallery." *Artforum* (October 1992): 104.

Bhabha, Homi. "Black Male: The Whitney Museum of American Art." *Artforum*, (February 1995): 86–87.

Brockington, Horace. "Logical Anonymity: Lorna Simpson, Steve McQueen, Stan Douglas." *The International Review of African American Art* 15, no. 3 (1998): 20–29.

——. "Lorna Simpson at Karen McCready Fine Art." *Review*, January 15 1997, pp. 13–14.

——. "Lorna Simpson at Sean Kelly Gallery." *Review*, October 1, 1997, pp. 39–40.

Budney, Jen. "Black Male." *Flash Art*, February 1995, p. 91.

Camhi, Leslie. "Clue: Lorna Simpson." *Village Voice*, October 7, 1997, pp. 87.

Cotter, Holland. "Lorna Simpson Standing in Water." *New York Times*, March 18, 1994, p. C23.

Dannatt, Adrian. "Black Conceptualist Month." *The Art Newspaper* (September 2001): 78.

Dector, Joshua. "Lorna Simpson at Josh Baer Gallery, New York." *Artforum* (January 1994): 90–91.

——. "Lorna Simpson at Josh Baer Gallery." *Artforum*, (January 1994): 90–91.

Enwezor, Okwui. "Social Grace: The Work of Lorna Simpson." *Third Text 35* (Summer 1996): 43–58.

Faust, Gretchen. "Lorna Simpson at Josh Baer Gallery, New York." *Arts Magazine* (September 1991): 80.

Feaster, Felicia. "Lorna Simpson at Sean Kelly Gallery." *New Art Examiner* (December 1997/January 1998): 53.

Foerstner, Abigail. "Simpson Challenges Racial and Gender Stereotype." *Chicago Tribune*, November 20, 1992, p. 104.

Fusco, Coco. "Lorna Simpson." *Bomb* (Fall 1997): 50–55.

Gaston, Diana. "Lorna Simpson at the Whitney Museum of American Art." *Camerawork* (Spring/Summer 2003): 34–35.

Glueck, Grace. "Lorna Simpson: 31 and Cameos and Appearances." *New York Times*, October 25, 2002, p. E35.

Goldberg, Vicki. "Photography View; The Artist Becomes a Storyteller Again." *New York Times*, November 9, 1997, pp. 2, 25.

Hagan, Charles. "Art in Review: Lorna Simpson." *New York Times*, November 17, 1995, p. C30.

Harris, Jane. "Lorna Simpson." *Time Out New York*, May 13–20, 2004, p. 66.

Hawkins, Margaret. "Wig Show Cuts to the Heart of Obsession." *Chicago Sun-Times*, April 22, 1994, pp. 23, 25.

Hayt-Atkins, Elizabeth. "Lorna Simpson at Josh Baer." *ARTnews* (December 1989): 162, 164.

Heartney, Eleanor. "Figuring Absence: Lorna Simpson at Sean Kelly." *Art in America* (December 1995): 86–87.

——. "Lorna Simpson at Josh Baer Gallery, New York." *Art in America* (November 1989): 185–86.

Hegarty, Lawrence. "Lorna Simpson at Sean Kelly." *Art Papers* (January/February1998): 56.

Holg, Garrett. "Lorna Simpson Reveals Truth Through the Eye of the Beholder." *Chicago Sun-Times*, December 13, 1992, p. 11.

Hollander, Kurt. "Crossover Dreams: inSITE 97." *Art in America* (May 1998): 46-49+.

hooks, bell. "Lorna Simpson: Waterbearer." *Artforum* (September 1993): 136–37.

Johnson, Ken. "Art in Review: Lorna Simpson." *New York Times*, October 3, 1997, p. E35.

——. "Lorna Simpson at Josh Baer Gallery, New York." *Art in America* (November 1992): 143.

Jones, Kellie. "In Their Own Image." *Artforum* (November 1990): 133–38.

——. "Lorna Simpson: Conceptual Artist." *Emerge* (January 1991): 40.

Jones, Ronald. "Lorna Simpson at Sean Kelly, New York." *Frieze* (January/February 1996): 67.

Joseph, Regina. "Lorna Simpson Interview." *Balcon Magazine* (Spring 1990).

Jusidman, Yishai. "inSITE 97, Tijuana/San Diego." *Artforum* (March 1998): 107–08.

Kendricks, Neil. "Film Projects Put Conceptual Artists in Motion." *San Diego Union Tribune*, July 13, 1997, p. E8.

Kimmelman, Michael. "Art Review: Constructing Images of the Black Male." *New York Times*, November 11, 1994, p. C1.

Lillis, Karen E. "Lorna Simpson at Josh Baer Gallery, New York City," *Art Papers* (March/April 1994): 61–62.

Lloyd, Ann Wilson. "Preserving Yankee History with International Ingenuity." *New York Times*, August 3, 2003, p. 2, 26.

Malen, Lenore. "The Real Politics of Lorna Simpson." *Women Artists News* (Fall 1988): 4, 8.

Malik, Amna. "Lorna Simpson: Then and Now at Irish Museum of Modern Art, Dublin." *Portfolio, Contemporary Photography in Britain* (December 2003): 90–92.

Marquardt-Cherry, Janet T. "B(l)ack Talk: African American Women's Confrontational Art." *Exposure 33 1/2* (2000): 53–60.

McNally, Owen, "Photographer's Works Expose Face of Racism," *The Hartford Journal*, October 3, 1989, p. B1.

Mifflin, Margot. "Feminism's New Face." *ARTnews* (November 1992): 120.

Nochlin, Linda. "Learning from Black Male." *Art in America* (March 1995): 86–91.

Novakov, Anna. "In Conversation with Lorna Simpson." *Atlantica* (Winter 1998): 172–78.

O'Grady, Lorraine. "Olympia's Maid: Reclaiming Black Female Subjectivity," *Afterimages* (Summer 1992): 14–115, 23.

Ottmann, Klaus. "Lorna Simpson at Josh Baer and The Wadsworth Atheneum." *Flash Art* (November/December 1989): 142, 143.

Paik, Tricia Y. "Lorna Simpson: Cameos and Appearances. Whitney Museum of American Art." *Art on Paper* (January/February 2003): 76.

Pollack, Barbara. "Turning Down the Stereotypes." *ARTnews* (September 2002): 136–39.

Princenthal, Nancy. "Whither the Whitney Biennial?" *Art in America* (June 2002): 49–53.

Richard, Francis. "Fall 2002 Previews: Lorna Simpson." *Artforum*, (September 2002): 74.

Richie, Mathew. "Lorna Simpson at Sean Kelly." *Flash Art* (March/April 1996): 112.

Saussy, Haun. "Lorna Simpson at Josh Baer Gallery, New York; Wadsworth Atheneum, Hartford, Conn." *Arts Magazine* (December 1989): 84.

Schjeldahl, Peter. "The Global Salon." *The New Yorker* (July 1, 2002): 94–95.

Schleifer, Kristen Brooke. "Taking a Fall: Lorna Simpson's New Do." *Print Collector's Newsletter* (July/August 1994): 92.

Scott, Andrea K. "Lorna Simpson at Sean Kelly Gallery, New York." *Tema Celeste* (November/December 2001): 81.

Sims, Lowery Stokes. "The Mirror the Other." *Artforum* (March 1990): 110–15.

Smith, Roberta. "At the Whitney, a Biennial with a Social Conscience." *New York Times* (March 5, 1993), pp. C3, C27.

——. "Linking Words and Images Explosively." *New York Times*, July 20, 1990, p. C26.

——. "Lorna Simpson at Josh Baer Gallery." *New York Times*, September 29, 1989, p. 36.

——. "Working the Gap Between Art and Politics." *New York Times*, September 25, 1988, p. H33.

Thorston, Alice. "Photographer Creates Images to Expand Your Mind." *Kansas City Star*, January 22, 1995, p. J3.

Tomlison, Glenn C. "Lorna Simpson." *Bulletin, Philadelphia Museum of Art* (Winter 1995): 36–37.

Turner, Grady T. "Lorna Simpson at Sean Kelly." *Art in America* (May 1998): 123.

Villaseñor, Maria Christina. "Lorna Simpson Nine Props: An Interview and Art Portfolio." *Paris Review 138* (Spring 1996): 72–76.

Wallach, Amei. "Lorna Simpson: Right Time, Right Place." *New York Newsday*, September 19, 1990, part II/9, 14.

Wilkes, Andrew. "Lorna Simpson." *Aperture 133* (Fall 1993): 14–23.

index

158